How to Identify a Forgery

How to Identify a Forgery

A Guide to Spotting Fake Art, Counterfeit Currencies, and More

Suzanne Bell, PhD

Skyhorse Publishing

Skyhorse Publishing books may be purchased in bulk at special discounts for sales promotion, corporate gifts, fund-raising, or educational purposes. Special editions can also be created to specifications. For details, contact the Special Sales Department, Skyhorse Publishing, 307 West 36th Street, 11th Floor, New York, NY 10018 or info@skyhorsepublishing.com.

Skyhorse® and Skyhorse Publishing® are registered trademarks of Skyhorse Publishing, Inc.®, a Delaware corporation.

Visit our website at www.skyhorsepublishing.com.

10 9 8 7 6 5 4 3 2 1

Library of Congress Cataloging-in-Publication Data is available on file.

ISBN: 978-1-62087-593-3

Printed in the United States of America

CONTENTS

PREFACE

Forensic science has become in the early 21st century what the space race was in the 1960s—an accessible and inspiring window into the world of science. The surge in popularity that began in the latter part of the 20th century echoes a boom that began in the later part of the 19th century and was labeled the "Sherlock Holmes effect." Today it is called the "C.S.I. effect," but the consequences are the same as they were a century ago. The public has developed a seemingly insatiable appetite for anything forensic, be it fiction, reality, or somewhere between.

Essentials of Forensic Science is a set that is written in response to this thirst for knowledge and information. Written by eminent forensic scientists, the books cover the critical core of forensic science from its earliest inception to the modern laboratory and courtroom.

Forensic science is broadly defined as the application of science to legal matters, be they criminal cases or civil lawsuits. The history of the law dates back to the earliest civilizations, such as the Sumerians and the Egyptians, starting around 5000 B.C.E. The roots of science are older than civilization. Early humans understood how to make tools, how to cook food, how to distinguish between edible and inedible plants, and how to make rudimentary paints. This knowledge was technical and not based on any underlying unifying principles. The core of these behaviors is the drive to learn, which as a survival strategy was invaluable. Humans learned to cope with different environments and conditions, allowing adaptation when other organisms could not. Ironically, the information encoded in human DNA gives us the ability to analyze, classify, and type it.

Science as a formalized system of thinking can be traced to the ancient Greeks, who were the first to impose systematic patterns of thought and analysis to observations. This occurred around 500 B.C.E. The Greeks organized ideas about the natural world and were able to conceive of advanced concepts. They postulated the atom (from the

Greek word *atomos*) as the fundamental unit of all matter. The Greeks were also among the first to study anatomy, medicine, and physiology in a systematic way and to leave extensive written records of their work. They also formalized the concept of the autopsy.

From ancient roots to modern practice the history of forensic science winds through the Middle Ages, alchemy, and the fear of poisoning. In 1840 pivotal scientific testimony was given by Mathieu-Joseph-Bonaventure (Mateu Josep Bonaventura) Orfila (1787–1853) in a trial in Paris related to a suspected case of arsenic poisoning. His scientific technique and testimony marks the beginning of modern forensic science. Today the field is divided into specialties such as biology (DNA analysis), chemistry, firearms and tool marks, questioned documents, toxicology, and pathology. This division is less than a half-century old. In Orfila's time the first to practice forensic science were doctors, chemists, lawyers, investigators, biologists, and microscopists with other skills and interests that happened to be of use to the legal system. Their testimony was and remains opinion testimony, something the legal system was slow to embrace. Early courts trusted swearing by oath—better still if oaths of others supported it. Eyewitnesses were also valued, even if their motives were less than honorable. Only in the last century has the scientific expert been integrated into the legal arena with a meaningful role. Essentials of Forensic Science is a distillation of the short history and current status of modern forensic science.

The set is divided into seven volumes:

☑ *Science versus Crime* by Max Houck, director of research — forensic science, West Virginia University; Fellow, American Academy of Forensic Sciences; formerly of the FBI (trace evidence analyst/anthropologist), working at the Pentagon and Waco. This book covers the important cases and procedures that govern scientific evidence, the roles of testimony and admissibility hearings, and how the law and scientific evidence intersect in a courtroom.

☑ *Blood, Bugs, and Plants* by Dr. R. E. Gaensslen, professor, forensic science; head of program and director of graduate studies; Distinguished Fellow, American Academy of Forensic

Sciences; former editor of the *Journal of Forensic Sciences.* This book delves into the many facets of forensic biology. Topics include a historical review of forensic serology (ABO blood groups), DNA typing, forensic entomology, forensic ecology, and forensic botany.

☑ *Drugs, Poisons, and Chemistry* by Dr. Suzanne Bell, Bennett Department of Chemistry, West Virginia University; Fellow of the American Board of Criminalistics; and Fellow of the American Academy of Forensics. This book covers topics in forensic chemistry, including an overview of drugs and poisons, both as physical evidence and obtained as substances in the human body. Also included is a history of poisoning and toxicology.

☑ *Trace Evidence* by Max Houck. This book examines the common types of microscopic techniques used in forensic science, including scanning electron microscopy and analysis of microscopic evidence, such as dust, building materials, and other types of trace evidence.

☑ *Firearms and Fingerprints* by Edward Hueske, University of North Texas; supervising criminalist, Department of Public Safety of Arizona, 1983–96 (retired); Fellow, American Academy of Forensic Sciences; emeritus member of American Society of Crime Laboratory Directors (ASCLD). This book focuses on how firearms work, how impressions are created on bullets and casings, microscopic examination and comparison, and gunshot residue. The examination of other impression evidence, such as tire and shoe prints and fingerprints, is also included.

☑ *Crashes and Collapses* by Dr. Tom Bohan, J. D.; Diplomate, International Institute of Forensic Engineering Sciences; Founders Award recipient of the Engineering Sciences Section, American Academy of Forensic Sciences. This book covers forensic engineering and the investigation of accidents such as building and bridge collapses; accident reconstruction, and transportation disasters.

☑ *How to Identify a Forgery* by Dr. Suzanne Bell. This book provides an overview of questioned documents, identification of handwriting, counterfeiting, famous forgeries of art, and historical hoaxes.

Each volume begins with an overview of the subject, followed by a discussion of the history of the field and mention of the pioneers. Since the early forensic scientists were often active in several areas, the same names will appear in more than one volume. A section on the scientific principles and tools summarizes how forensic scientists working in that field acquire and apply their knowledge. With that foundation in place the forensic application of those principles is described to include important cases and the projected future in that area.

Finally, it is important to note that the volumes and the set as a whole are not meant to serve as a comprehensive textbook on the subject. Rather, the set is meant as a "pocket reference" best used for obtaining an overview of a particular subject while providing a list of resources for those needing or wanting more. The content is directed toward nonscientists, students, and members of the public who have been caught up in the current popularity of forensic science and want to move past fiction into forensic reality.

ACKNOWLEDGMENTS

I would like to acknowledge the efforts of my coauthors in this set for their work; Frank Darmstadt, my patient editor; and Ms. Suzie Tibor, for her assistance in obtaining many great photos for this and the other volumes.

INTRODUCTION

A forgery is a purposeful attempt to make a fraudulent copy of something, whether it is a signature, money, or a piece of art. If an object is fraudulent, this means that its origin is not what it is presented to be. A fraudulent painting, for example, is one that was not painted by the artist shown in the signature. Fraudulent money is not genuine currency, and a forged check is not signed by the person whose name is on the check.

Fakes and forgeries have existed since humans began to create art and written language. Laws against forgery existed in ancient Egypt, where craftsmen were skilled in making glass imitations of precious gemstones. In that same area of the ancient world, Phoenicians sold counterfeit Egyptian relics. Later, the Romans became adept at fabricating copies of Greek art, which was fashionable in the upper circles of Roman society. Early cultures used shells and other natural objects as money, but once governments began to mint coins and printing paper currency, counterfeits appeared. From the earliest human history, if something was perceived to be of value, it was an attractive target to forgers.

How to Identify a Forgery, one volume in the Essentials of Forensic Science set, discusses how science has become a key partner in the battle against forgers. If a question arises about the authenticity of a document, such as the signature on a will, a forensic scientist is likely to be involved in the investigation. Within forensic science, this discipline is called questioned documents examination or forensic document examination, and it covers written, printed, and computer-generated papers. The book presents how forensic document examiners analyze evidence that includes the following:

- documents produced by handwriting
- typewritten documents

- copiers (photo and xerographic)

- forms and carbon copies

- computer printers (laser, inkjet, and dot matrix),

- machine printed documents (check writers and cash register receipts)

- facsimile machines (FAX) documents

- lottery tickets

- voting ballots

- stamps

- envelopes

The types of questions that the examiner tries to answer are as follows:

- Who wrote the document?

- Is the person who signed it the same person who wrote it?

- Was all the writing done at one time?

- Has anything been altered?

- When was it written?

- In what order was it written?

Document examination typically begins with the evaluation of class characteristics of the evidence and proceeds to individual characteristics. A class characteristic is something that allows the examiner to categorize evidence. For example, class characteristics of inks would be color (red, blue, black) and type (ball point, felt tip, or gel). Individual characteristics include the person's handwriting style or defects in the roller ball of a pen's tip. Photography, microscopy, and spectroscopy are important tools at the examiner's disposal, supplemented with large databases of inks, papers, and so on maintained by professional organizations and law

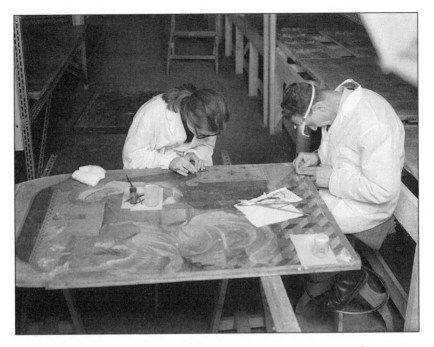

Anything of value can be faked or forged, including art. To uncover forgery, all the tools of science and history may be needed. This photo shows art restoration specialists working in Florence, Italy. Knowledge gained by such work is invaluable in detecting fakes and forgeries. *(AP)*

enforcement agencies. Increasingly, digital imaging and enhancement is becoming an important element of the analysis of evidence.

The book also discusses how counterfeiting is one of the oldest types of forgery. Money was once principally coinage produced by pressing images into precious metals; however, modern money is primarily paper, and although coins are still used, counterfeiters rarely counterfeit pennies and quarters when they can use computers, scanners, and color printers to make counterfeit bills. When coins are forged, usually these are fakes of collectable or rare coins valued much as are works of art. Similar statements can be made for collectable items such as stamps.

Fakes and forgeries of art and historical objects has been a problem for centuries. When paintings by famous artists such as Cezanne and Leonardo da Vinci are worth millions, there is great incentive to create fakes to sell to unwitting buyers. Even historical artifacts and scien-

tific experiments can be faked or forged, often for publicity. The term *hoax* describes a fake created for a reason other than profit. Hoaxes are not criminal or illegal and are perpetrated as a practical joke or to attract attention. As an example, a recent scientific study of the Shroud of Turin, the mythical burial cloth of Jesus, showed that it was likely a hoax perpetrated by a medieval painter. No one will ever know the reason, but it might have been to attract religious pilgrims to the church where the shroud was displayed. Such pilgrims brought money and prosperity to the towns to which they traveled. The Piltdown skull was accepted as the missing link between humans and apes until it was revealed that the skull was from the medieval period and the jaw was from an orangutan. It took nearly a half-century for the hoax to be revealed, and there is still no strong evidence as to who was responsible. The reason for the hoax may have been to embarrass early advocates of Darwin's theories of evolution. Recent hoaxes include phony UFO photos.

How to Identify a Forgery points out how fakes and forgeries are not limited to objects such as writings, art, or bones. Forensic linguistics is an emerging field that evaluates questioned utterances, related to what people say and how they say it. For example, forensic linguistics can be used to identify a region where a person is from, to determine the author of a document or determine if two documents were written by the same person, and to clarify the meaning of statements made in court or to law enforcement officials. Linguists also work with questioned document examiners and voice recognition experts. One of their most common tasks is in the area of speaker or author identification, comparison, authentication, and analysis. Some authors consider forensic stylistics to be a separate specialty focusing on the style of speech (oral or written) characteristic of a group or individual.

Analysis of documents or speech involves study of the types of words used, word choice (for example *pop, soda,* or *Coke* to describe a carbonated beverage), grammar, accent or dialect, spelling, error patterns, and sentence structure. Statistical analysis and comparison to general usage patterns are employed to assess where a speaker might have come from or where he or she might live. Similarly, if a will is suddenly changed on the eve of a person's death, linguists can compare known writings of the person with the will to see if the questioned writing follows the same

pattern as that of the new will. Perhaps a person always misspells certain words, such as *there's* when they mean *theirs*. If a document appears in which the word is spelled correctly, that would be suspicious. Many of these types of analyses are used as investigative tools more than in courtroom testimony directly. For example, linguistic analysis alone would not be able to prove that the author of a threatening letter lived in a certain region, but knowing that it is likely could prove a great help to investigators.

Another area of forensic linguistics is discourse analysis, which evaluates courtroom transcriptions or other legal statements such as confessions for accuracy, perception, intent, and meaning. For example, the exclamation "drop it!" might refer to a weapon or to a request for someone to drop a topic of conversation, depending on the context. When the phrase is written, it is not clear which was meant unless the rest of the conversation can be used as context. How such a statement was meant and how it was interpreted could be critical. Discourse analysis can also be important when translations are involved since the translators must often use their judgment to select words or phrases in one language to express the meaning of another. For example, two translators can take the same statement and derive two different translations with differences that might seem subtle in one language but substantial in the other. Word selection, sentence construction, and other linguistic elements become critical in conveying meaning.

Forgers, fakers, and hoaxers have adopted the modern tools of computers, printers, and scanners to create questioned documents and counterfeits. Art forgers have learned that their work is more convincing if they use genuine older canvas rather than the modern mass-produced canvases. The scientific detection of forgery has kept pace, and examiners have a range of scientific tools and techniques at their disposal. Questioned document examiners use microscopes and spectrophotometers to study ink and paper. Computer programs study digitized handwriting. X-ray analyzers are used to study pigments in paintings to determine if the paint is authentic. Scientists working in forensic labs work hand-in-hand with artists, museums, linguists, and historians to study artifacts and documents. The race between forgers and those who uncover their work will never be won by either side; as science and technology advance, so do the techniques of forgery.

What Is in This Book

How to Identify a Forgery will cover the forensic examination of physical evidence that is suspected of being faked, forged, or fraudulent. The book begins with an overview of documents, both handwritten and mechanically printed, how they are created, and what features can be used by forensic investigators to detect fakes and forgeries. Because documents are not the only items that can be faked, the first chapter will also introduce forgery of art and historical artifacts of value such as paintings, maps, and sculpture. The second chapter describes the scientific tools and techniques used by forensic document examiners to examine evidence. Their most important tool is often the microscope, so that topic is given the greatest attention.

Nearly all forgeries, be they of documents, paintings, or maps, contain inks, dyes, or paint. These materials provide much important information to forensic examiners and have been instrumental in revealing uncounted numbers of fakes and forgeries. The third chapter describes the chemistry and forensic value of these materials and reveals how they are used in actual casework. The fourth chapter builds on this information and focuses on forensic document examination. Chapter 5 concentrates on a particular type of document—currency and paper money. The final chapter delves into the world of forged art and history, which relies on the same kinds of scientific tools and expertise as forensic document examination, but applies them in fascinating ways.

1

History and Pioneers

This chapter explores the history of document writing and introduces the pioneers of forensic documentation examination. The history of questioned documents and forgery traces back to the beginning of writing. Early civilizations such as the Sumerians and Egyptians were among the first to introduce writing for communication and record keeping. Previous to that, humankind had used pictures such as cave drawings and diagrams to communicate, but there was not the same structure or organization to those drawings as there are in written language. Writing is language that is organized into parts, such as nouns and verbs, and construction rules that allow symbols to be combined to convey new meaning. As far as we know, pictures had no such rules or components and so were not an organized or standardized method of communication.

It is assumed that written language emerged in early civilizations because for the first time large numbers of people were concentrated in small areas. Prior to the first permanent settlements, people lived in small bands that moved from place to place to find food. Once humans learned about agriculture, they settled in fertile areas such as the Nile

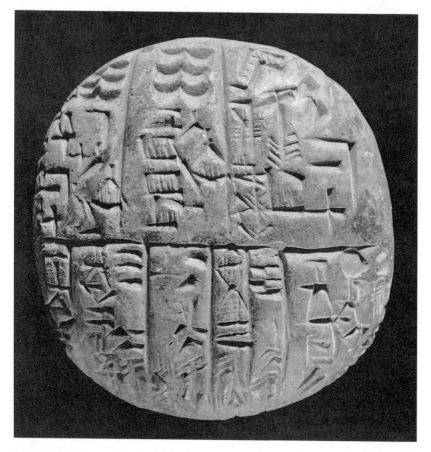

An example of ancient cuneiform writing. One of 15,000 tablets in the Royal Archives (2400 B.C.E.) opposite the Audience Court of Palace G, Ebla, Syria, excavated by Paolo Matthiae in 1975 *(Art Resource)*

(modern Egypt) and Tigris-Euphrates (modern Iraq) river valleys where they could grow crops. As a result, these people had a more reliable source of food and could stay in one place. A stable food supply resulted in an increase in population and the need for organization and record keeping. This spurred the development of not only writing but also laws, currency, and taxation to provide the resources to manage a large community.

Money and taxes provided motive and opportunity for forgery; laws helped communities to define these activities as crimes. Along with record keeping came the need for individuals to sign and validate agree-

ments and documents. This mark of validation had to be unique to the individual, and it had to be recognized by the lawful authorities as a mark of authentication. If a person placed a signature on a document, that meant that the person agreed to the terms in it and would abide with and stand by the contents of the document. In other words, people needed a signature.

The refinement of writing as a recording-keeping method and the use of signatures did not immediately create the forensic discipline of forensic document examination. There are reports of document examination cases from the Middle Ages, but forensic science, let alone forensic document examination, did not appear as a recognized area of study until well into the scientific and industrial ages.

THE BEGINNINGS OF FORENSIC DOCUMENT EXAMINATION

The examination of questioned documents was one of the first disciplines recognized as part of forensic science, and forensic science itself started to emerge as a distinct discipline in the late 1800s. The following text discusses a number of pioneers in the field, including Edmond Locard, Hans Gross, Alphonse Bertillon, and Albert S. Osborn.

Edmond Locard (1877–1966), a Frenchman, was instrumental in taking theories and ideas from what was then called police science and applying them to casework. Trained in law and medicine, he was influenced by the writings of Hans Gross and Sir Arthur Conan Doyle, who wrote the Sherlock Holmes stories and novels. In 1910 Locard established a forensic laboratory in Lyon, France. The laboratory was primitively equipped by modern standards. Despite this, he was able to establish a reputation and to increase the visibility of forensic science across Europe. Locard was interested in microscopic evidence, particularly dust, and believed that such trace evidence was crucial in linking people to places. Although he apparently never used the exact phrase himself, Locard is most famous for Locard's Exchange Principle, which evolved from his studies and writings. The principle is usually stated as "every contact leaves a trace" and reflects his belief that every contact between a person and another person or a person and a place results in the transfer of materials between them. Most transfer evidence is micro-

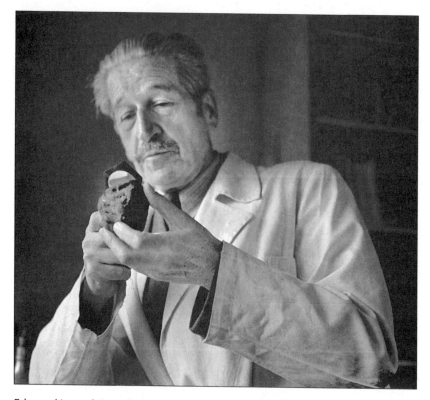

Edmond Locard, French doctor and criminal jurist *(The Image Works)*

scopic, and it may not last long, but the transfer does occur, and it is the task of the forensic scientist to identify and interpret those traces. The success of Locard's methods encouraged other European nations to form forensic science laboratories after the conclusion of World War I. In Lyon he founded and directed the Institute of Criminalistics located at the University of Lyon, and he remained a dominant presence in forensic science into the 1940s.

Hans Gross (1847–1915), an examining magistrate in Graz, Austria, is the man credited with coining the term *criminalistics* to describe what was then an infant science. Gross viewed forensic science holistically and believed that experts from diverse fields would contribute to the analysis of physical evidence and solving crimes. He understood the value of biological evidence, soil, dust and many other types of transfer and trace evidence. In 1893 he published the first textbook in forensic science,

translated into English as *Criminal Investigation,* and started the journal *Kriminologie,* which is still published today. Gross was a pioneer in the field who exerted a strong influence on his contemporaries, including Edmond Locard.

Alphonse Bertillon (1853–1914), a French forensic scientist, developed the first systematic method for the identification of suspects and criminals, setting the stage for fingerprinting, which ultimately replaced it. The system, called anthropometry or Bertillonage, incorporated 11 body measurements along with descriptive information and photographs stored on a card, similar to modern fingerprint cards. After development and implementation in 1883, the system spread throughout the world while elevating Bertillon to the forefront of pioneering forensic scientists.

Bertillonage was the accepted standard of individual identification until the early 1900s, when problems with the system, coupled with growing evidence that fingerprints were individually unique, led to a gradual abandonment of the body measurement system. Bertillon resisted the use of fingerprints, although he did add space to his data cards for the inclusion of fingerprint data from the right hand. Ironically, despite his reluctance to accept fingerprinting, Bertillon was the first forensic scientist in Europe to use it to solve a case.

In addition to anthropometry, Bertillon is also remembered for his contributions to the development of crime laboratories as distinct entities within law enforcement. He was instrumental in directing the evolution of what amounted to specialized photographic studios into identification bureaus focusing on his system of body measurements. This system, *portrait parlé,* was widely adopted as a standard identification tool by many police departments. Although not a crime laboratory in the modern sense, his identification bureau helped pave the way that led to further improvements and expansion into other areas of crime science and criminalistics. He also advanced work in the fields of questioned documents and crime scene photography.

Albert S. Osborn (1858–1946) is considered to be a pioneer of document examination in the United States and wrote a book entitled *Questioned Documents* in 1910, along with a later revised edition. The books are still cited in the field, and Osborn's sons (Paul and John) continue as active examiners. Osborn senior was involved in the Lind-

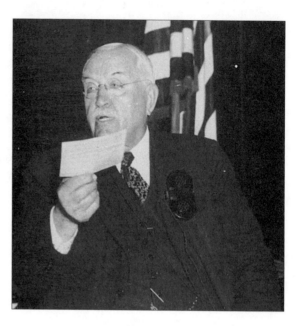

Albert S. Osborn
testifying at the
Lindbergh kidnapping
case trial in January
1935 *(Corbis)*

bergh kidnapping case in 1932, a crime that was instrumental in bringing forensic evidence, including documents, to the public's attention. He was the moving force behind the formation of the first professional society in the United States devoted to the forensic examination of documents. The American Society of Questioned Document Examiners (ASQDE) was founded in 1942 with Osborn as the first president. He remained in that position until his death in 1946. The ASQDE and other professional organizations (the American Academy of Forensic Sciences and the Canadian Society of Forensic Science) joined to form the American Board of Forensic Document Examiners (ABFDE) in 1977. The role of the board is to provide professional certification of document examiners. There are no degree programs specifically for document examination, but certification with the ABFDE requires that the examiner have a bachelor's degree along with the requisite training, which retains a strong element of traditional apprenticeship work.

Forensic document examination is now part of many crime laboratories in the nation and across the globe. In the United States, several federal agencies maintain capability in forensic document examination

and perform research in the field. The Federal Bureau of Investigation has a documents unit. The United States Postal Inspection Service has forensic labs that include questioned documents units, as does the United States Secret Service and the Bureau of Alcohol, Tobacco, Firearms, and Explosives. The Secret Service has developed and made available the FISH system, the Forensic Information System for Handwriting, to assist other agencies. It also has the exclusive responsibility for the investigation of counterfeiting of currency in the United States.

SIGNATURES

When a person thinks of questioned documents and forgery, he or she often thinks of someone forging someone else's signature. The way a person signs his or her name is considered a unique representation of that individual. Legally binding documents such as checks, wills, and applications require a signature to be considered authentic. Early signatures, like early writing, used symbols. Other cultures appear to have used a fingerprint as a mark of individuality. Even ancient cave paintings are decorated with the outline and imprints of hands, perhaps as a signature by the artist.

To create a signature, a person must be able to read and write, or at least create a distinctive mark. How does this mark become distinctive? Consider the script letter *a*. It is made with the same parts, but each person adds individuality in the way that he or she makes and combine these parts. The way in which an *a* is constructed from its parts generates the class characteristics of the handwriting, and the way in which each person writes it includes the individual characteristics. Many features vary such as the slant used, whether there is an open loop where the pencil changes direction, where the pencil is lifted from the paper, whether the loop is closed, the relative size of the loop, and so on. The combination of these variations makes a person's handwriting unique. When several letters are combined in a signature, the effect is more dramatic.

Block printing also has unique aspects. For example, the angle at which a person holds a pen or pencil varies, meaning that pressure on the paper and the line thickness and width can vary as shown in

the figures. The order in which the parts of the letters are made is not set, meaning that there will be pencil lifts and line crossings that depend on the order. Handwritten words and letters, whether in cursive or print, have unique elements arising from the writer. These are the individual characteristics that create a distinct signature. When people try to forge or copy someone else's signature, they must successfully hide the characteristics of their own writing and mimic those of the person whom they are trying to copy. This is not as easy as it might seem.

There are two methods by which forgers try to copy a signature: drawing and tracing. A skilled, questioned documents examiner is trained to identify the characteristics associated with both methods. To trace a signature, the forger first must be able to see the genuine signature on the paper. This can be accomplished by using a light box or something as simple as bright sunlight streaming through a window. The document with the signature to be copied is placed on the light box, and the forger places the paper on which the forgery will be is placed on top of it. When the light is turned on, the forger can see the original and can trace it.

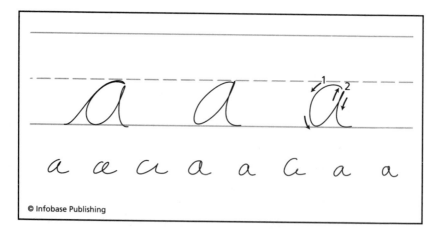

© Infobase Publishing

How one learns to write a script may be the same as how others learn, but how each person writes it is different. Usually children are taught to start at the top of the letter, halfway to the top of the line, assuming it is a lower case *a*. This is shown by the "1". A circle is made and closed and, without lifting the pencil, a downward line is added ("2").

"S" 1 stroke	"Y" 1 or 2 strokes	"T" 2 strokes (different directions)	"E" 2, 3, or 4 strokes
S	1Y 2Y	1↓ 2T	1⊏ 2E
		1 2T↓	1L 2⊨ 3E
		1↑ 2T	1\| 2⌐ 3⊏ 4E
		1↓ 2T	

© Infobase Publishing

Variations in block printing can arise from the way or the order of pen strokes.

While this sounds like a good approach, telltale signs are left behind. The trace may be nearly perfect, but if there are faint marks in the original, such as where the pen was barely lifted off the paper, it may be too faint to be seen even if a bright tracing light is used. The forger will likely miss these subtle features. Because the forger must move the writing tool slowly to trace, the way in which the pen is lifted, the pressure, the angle, and the speed will differ from those used in the original signature. The pen will not be lifted at the same places as where the original writer had it, and the sequence of lines will not be the same. In fact, the trace may be too perfect in that it could look like an exact copy of the signature, something rarely seen. If the document that was used as the source of the trace is found, the fact that it is a near-perfect copy is strong evidence that it was forged. If an individual were to write 10 signatures, each one would be different even though they all came from the same person. So while at first glance a traced signature may look genuine, careful examination can usually reveal the tracing.

The other method used to forge a signature is the drawing or freehand method. The forger practices reproducing the signature by drawing it in a way similar to how an artist looks at a scene and attempts to draw it. This method avoids the problems associated with tracing, but it is usually detectable by a skilled examiner. Unless the forger practices extensively and can write the forged signature nearly as fast as his or her own, the forged signature is written slowly. As a result, the line may show wiggling, hesitations, and pen lifts in places that the genuine signature

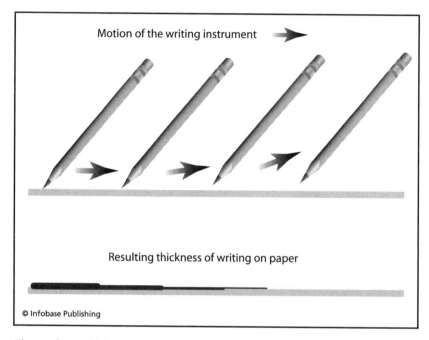

Motion of the writing instrument

Resulting thickness of writing on paper

© Infobase Publishing

The angle at which a pen or pencil is held can also introduce variation and uniqueness, as can pressure used. As the pen nears the end of a letter, the writer will start to lift the pen or change the angle with which it is in contact with the paper. This will change the thickness of the stroke on the page.

does not. The direction and the order of how the letters are constructed may differ.

Signatures change and evolve over a person's lifetime as children and teenagers experiment and try different things. For example, teenage girls often use flourishes and decorative techniques such as little flowers for dots on an *i* that fade as they enter young adulthood. Similarly, if a person is ill, has poor eyesight, or is intoxicated, their signature will show signs of these states. Drifting over lines, trembling lines, and odd shaping are all possible, and these situations often present challenges to identification. How document examiners analyze handwriting and detect forgeries will be described in detail in the next chapter.

Handwriting is but one method of creating documents, and increasingly, not the most common. Mechanical and electronic means are rapidly supplanting handwriting for most business and day-to-day record

keeping. Such printing creates new opportunities for forgers and a different set of challenges for document examiners.

MECHANIZED AND COMPUTERIZED PRINTING

Writing became mechanized with the invention of the printing press, generally credited to Johann Gutenberg (ca. 1397–1468); however, the Chinese and other cultures had used movable type before the 1400s. The fundamentals of early printing presses still apply today. Early printing was composed by placing individual block letters into a tray organized in rows. Because each block was hand carved, a block *A* used in one town would not be the same as a block *A* used in another. This provides another example of the difference between class characteristics and individual characteristics. Even if the style of the *A* was the same in both carved blocks, the way in which it was carved created unique markings on each. Just like handwriting, the letters share the same class characteristics but also have individual characteristics. This pattern continues even into the age of computer printing and copying.

The typewriter was the next significant advance in printing technology after the printing press. The first typewriters were introduced approximately in 1870 and became the most important piece of office equipment until word processors became widely available a century later. A typewriter consists of letters stamped onto metal plates that create a letter by impacting paper through an inked ribbon. Nicks, cuts, abrasions, and other marks on the individual letter keys may be sufficient to link a typed document to a specific typewriter.

Modern typewriter keys are mass-produced. As a result, there should be little variation in the keys when they are brand-new, at least when the typewriter leaves the factory. Since each typewriter is used differently, differences arise. Consider two typewriters coming off the same assembly line, one right behind the other. Both are identical makes, models, and brands; in fact, these are what distinguish them from typewriters made by other companies. These are class characteristics, and as the two typewriters leave the factory, these should be identical or nearly so on both machines.

Suppose that one typewriter goes to a busy office where it is used to type hundreds of documents a year, correlating to thousands of

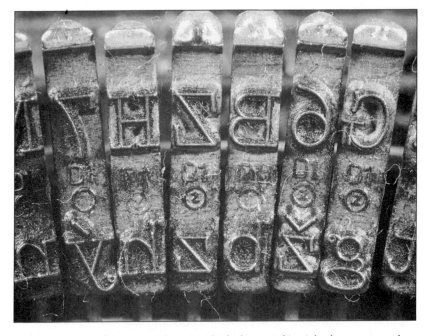

A close-up view of typewriter keys in which the metal is nicked, compressed, stained, and worn, showing an example of wear characteristics *(Shutterstock)*

key strikes. Each time the key is used, a tiny bit of wear occurs. As people work on the typewriter, cleaning and maintaining it, the keys will be scratched or otherwise damaged. Suppose the other new typewriter goes to a person who rarely uses it. The keys remain nearly the same as when the machine was purchased. The typing produced by one typewriter can be distinguished from the other because each was treated so differently. These wear patterns in the keys can help determine whether a document was typed on one typewriter or the other, even though when they left the factory, it would not have been possible to do so. Collectively, these kinds of marks are called machine wear or machine defects. The concept of characteristic wear patterns carries through to any kind of mechanical printing, be it a printing press or a copy machine.

In addition to the class and individual characteristics, typewriters have other features that can be exploited by forensic examiners. Typewriters use rollers to move paper in front of the inked ribbon. The image of a letter is placed on the surface of the paper by a key striking the rib-

bon. Some rollers leave distinctive marks on paper, and these marks can change over time as the rollers wear out. These are the characteristics that can individualize typewriting and that can be used to link a document to a specific typewriter. A single-use ribbon retains the image of typed letters that are struck through it, which may be of use to a forensic analyst.

Typewriters can also possess what are called accidental characteristics. These are markings that were not intended and arise (usually) by accident. As an example, suppose that a factory is manufacturing the key for the letter K using a stamping machine. After one key is stamped, a small metal shaving falls onto the surface of the stamp. The next K key will bear an imprint of that shaving. The shaving may stay there for days, or it may fall away immediately, but at least one K key now has an accidental characteristic that may be useful later for linking documents to that key and to the typewriter in which it was installed.

The best-known class characteristic of typewriters is the fonts they produce. There are two fonts common in typewriters, Pica and Elite. Pica spacing allows for 10 characters per inch, while Elite allows for 12. Different companies created slightly different typefaces over the years, and by comparison with databases of typefaces, it is sometimes possible to identify the typeface, make, and model of a typewriter used to create a document. The construction of letters over the years has evolved as well; for example, older typewriters often created M and W with the middle reaching to the same height as the end lines. Later typefaces changed to have the middle line about half the length of the two end lines. Proportionally spaced fonts were also introduced, with variable spacing between letters as opposed to the fixed spacing of Pica and Elite. IBM introduced the Selectric typewriter in 1961, which used an interchangeable ball element instead of individual keys, and as the century drew to a close, the functions of newer typewriters began to merge with that of computer word processors. Knowledge of how typewriting has changed over the years can be used to assign a bracket of dates during which a document was typed. As an example, if a will was typed in the early 1900s, it could not possibly contain characters that are associated with a Selectric typewriter.

The forensic document analyst has many tools available to analyze typed letters. The grid method involves placing a grid over a document

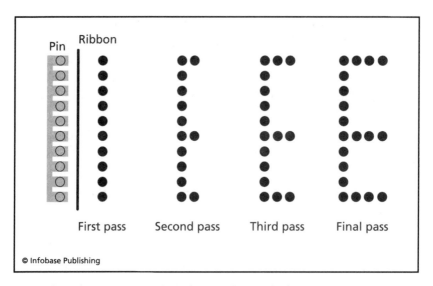

© Infobase Publishing

How a dot-matrix printer creates a letter. Ink is applied to the paper in several passes. Dot-matrix printers are still used in many large-volume printing operations such as cutting checks.

and using it to evaluate spacing, font, and defects. A comparison projector can be used to project large images of documents for side-by-side or overlapping comparisons. Inks in ribbons can be evaluated, as can carbon paper and correction inks and fluids. Alternative lighting and fluorescence can also be used to investigate the characteristics of the ink, a topic discussed in detail in the next chapter.

Following typewriters, the next innovation in mechanical printing was the computer printer, and forensic document examiners have adapted their methods accordingly. Early computer printers had many features in common with typewriters, such as ribbons. One of the first computer printers available, still widely used for printing forms and checks, is the dot matrix printer. Like a typewriter, a dot matrix printer uses an impact method to create letters by striking paper through an inked ribbon. The letter is formed by a series of dots mounted on a printing head. Multiple passes of the print head coupled to selective activation of the pin generates the letters. Dot matrix printers have class characteristics as well as machine defects and accidental characteristics that can be used for comparison.

Computer printing quickly moved to nonimpact printing technologies such as laser printers and ink-jet printers. Photocopiers, similar to laser printers, are also nonimpact. Ink-jet printers work on much the same principle as dot matrix printers except that ink is sprayed from the print head onto the paper in tiny target areas. Laser printers and copiers work on a different principle, as shown in the figure. At the start of the print cycle, a rotating drum surface is charged electrostatically in a fine grid pattern. Like the scanner and CCD, the finer the grid, the higher the resolution that is possible. A laser selectively scans the grid, discharging any grid square that it strikes. This creates a pattern that corresponds to

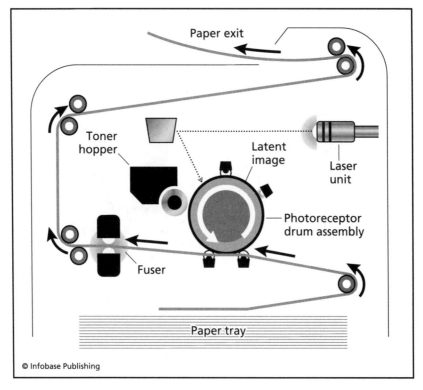

© Infobase Publishing

A simplified overview of how a laser printer works. A laser light, controlled by the computer, scans the photoreceptive drum, which is shown in detail on the next page. The laser discharges areas corresponding to the image. The drum rolls past the toner hopper, and toner sticks to the areas on the drum where the charge remains. The drum rolls onto the paper as the paper moves past and the toner is bonded to the paper by the fuser.

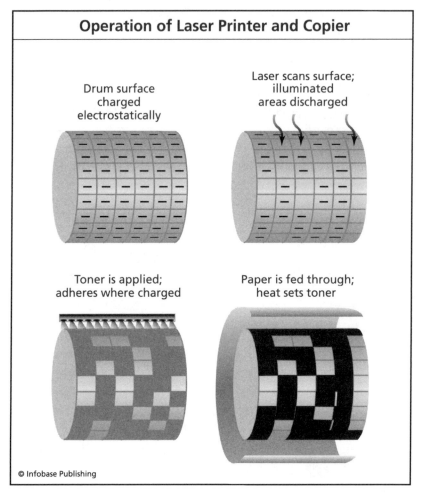

Operation of Laser Printer and Copier

Drum surface
charged
electrostatically

Laser scans surface;
illuminated
areas discharged

Toner is applied;
adheres where charged

Paper is fed through;
heat sets toner

© Infobase Publishing

A close-up of the rotating drum assembly found in laser printers and copiers

lines from the image on the drum. The next step is to apply color, either black and shades of gray or color using toners.

Toner is a dry material that feels like powder but contains waxy plastic. Finer grain sizes of toner allow for sharper lines and resolution in the printed image. Each color of toner is kept in a separate toner cartridge. Color copiers usually have three colors in addition to black: yellow, magenta (a light rose red), and cyan (a bluish purple). The color combination is often abbreviated to CMYK, with the K representing black. These colors can be combined to create thousands of other colors.

Toner that is negatively charged is applied to the drum and adheres wherever the charge remains. Paper, also given an electrostatic charge, is rolled on the drum, transferring the toner from the drum to the surface of the paper. The toner is fused to the paper by heat that melts the waxy toner so that it adheres to the paper. The final step in the process is to remove the latent image from the drum using a discharge lamp. The drum is then ready to receive the next image.

Many copiers are composed of a scanner integrated with a laser or inkjet printer. Once costly and complex, optical scanners are now common computer components. They are also being used for counterfeiting and forgery schemes. One scanner design incorporates a charge-coupled device (CCD). CCDs are also used in digital cameras, and their function is to capture light and store it as electrical charge. A CCD detector is laid out as a grid of tiny individual sensors that fill with charge in proportion to the amount of light to which each is exposed. The more light, the more the stored charge; the finer the grid, the higher the resolution of the detector. Whether a CCD is in a camera or a scanner, its function is to capture light and capture an image that can be translated to electrical charges.

To use a CCD scanner, a document is placed on a glass bed and the lid is closed. A bright white light illuminates the paper, and a unit called a scan head moves across the paper, directing an image through mirrors to the CCD, which is made up of many tiny photosensitive elements. The smaller the individual elements in the CCD, the higher the resolution of the scanner. As the scan head moves across the paper, the elements record the signal that reaches them, which corresponds to the density of printing at that location. Using filters allows certain colors of light through to the CCD, and consequently it is possible to make color scans as well as grayscale. The image can be stored digitally in a computer file or directed to a printer for making a copy of the image.

As printing technologies advance and evolve, so must the techniques used in forensic document examination. The fundamentals do not change, however, and linking a printed document to the device that printed it uses the same general principles that document examiners use for handwriting. First, the examiner must determine what type of machine generated the printing in question, be it typewriter, printer, FAX, photocopier, or something else. Next, the examiner works with

class characteristics to narrow down the possible sources of the printing. This is as far as the examination usually can go unless a device is found for comparison.

For example, a document examiner may receive as evidence a note used to rob a bank. The document is printed, and the examiner first looks and finds that a laser printer was used. The examiner may be able to study characteristics of the toner and inks to further limit what companies could have made the printer. That is about all the examiner can do at that point. However, if a suspect is identified and a laser printer found at the suspect's workplace or home, then the examiner can work with accidental and wear characteristics to determine whether the note could or could not have been printed on either of those computers.

ELECTRONIC AND DIGITAL SIGNATURES

As computers, email, and the Internet are used more and more for business and legal transactions, the need for the electronic equivalent of a signature has become obvious. While a traditional signature is made by a person directly on paper, an electronic signature is more complex, and there are several ways in which a person can "sign" an electronic document. Each method opens the door to forgery and the need for methods of forensic detection. The more electronic the system becomes, the greater the need for computing expertise, and many aspects of forensic document examination are beginning to overlap with forensic computing, a topic that will be discussed shortly.

One straightforward way to create an electronic signature is to sign a piece a paper and then scan it into a computer file. The scanned copy can then be added into any typed document. While convenient and easy, anyone who has access to the scanned signature can insert it into any document. An electronic signature is not necessarily an authentic one, even though it is an exact copy of the original. The heart of the problem is the lack of personal contact and verification. When a person forges a signature on a check or credit card slip, the forger almost always comes into face-to-face contact with the person accepting the document. This does not guarantee that there will be no forgery, but at least the criminal has to forge the signature while someone is watching. With documents sent electronically, there often

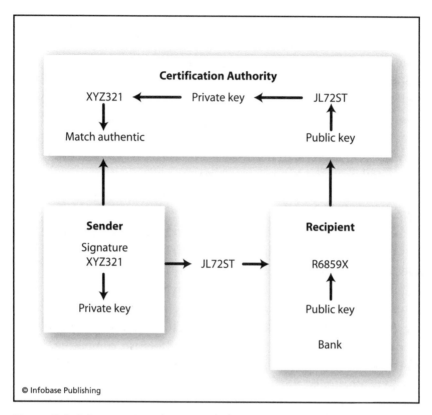

How a digital signature is authenticated. The user creates the document and attaches a digital signature that is encoded by a private key. The document is sent to the recipient, here a bank. The bank needs to know if the signature is valid, so a computer uses a public key to encode the signature again. This string is sent to a certification authority that has access to both the public and private keys. If the public key and private key versions match when decoded, the signature is deemed authentic.

is no contact between the forger and the recipient. A woman walking into a store with a checkbook stolen from a man named John Smith will not successfully cash the check no matter how well she can forge John Smith's signature. However, if she steals John's credit card and uses it to buy things over the Internet, the merchant will never know that the person pretending to be John Smith is a woman. This woman could just as easily put John's scanned signature on a document and transmit it electronically.

To overcome this problem, the concept of a digital signature was born. The idea is still being refined, but it is becoming more common. In general, a digital signature is a sequence of characters that the user generates or has generated for them by specialized software. The sequence is coded using a private key. This key is a mathematical formula or operation that the user has, but the recipient does not. To determine if the document is authentic and comes from the person that is supposed to be sending it, a third party is needed. The third party is called a certification authority and has access to both the public and private keys. By decoding and comparing, the certification authority can determine if the document is authentic.

As writing moved from handwriting to mechanical and computer printing, forensic document examiners were able to extend their tools and techniques related to classification and identification to the new printing methods. This is not true of moving from handwritten signatures to electronic ones. Electronic and digital signatures are changing the field of questioned documents and leading to an overlap with a new forensic discipline loosely referred to as forensic computing. Since a person does not actually put pen to paper to create an electronic signature or document, the traditional 20th-century tools of questioned document examination do not apply or, at the very least, need extensive modification.

INK AND PAPER

Many factors in addition to writing and printing can be helpful in detecting fakes and forgeries. The ink used in a document can provide invaluable information. The composition of inks is much like paints—a solvent base (water or other), coloring materials (either inorganic pigments or organic dyes, natural and synthetic), and other additives to control thickness and appearance. The oldest ink, called India ink but originally used in China, consists of carbon black (ground charcoal) suspended in water. Adhesive gums to attach the carbon to the paper and varnishing components are used to protect the finish. Iron gallotannate inks, the type used in fountain pens, contain inorganic colorants and tannic acid. Ballpoint inks contain synthetic dyes dissolved in organic solvents, with other additives that maintain a thick consistency. Newer gel pens, now

made by most manufacturers, contain synthetic dyes impregnated into the gel. Unlike ballpoint pens, the primary solvent in gel pens is water. Gel pens come in a dazzling variety of colors, including glittered and sparkling variants.

The variety of writing instruments available is nearly as rich as the variety of inks. Feathers and fountain pens have been used with India ink, while modern writing instruments range from ballpoints to felt tips to gel pens. The ballpoint pen was developed in 1939 and made its way in significant quantities to the United States by 1945. Ballpoints work by delivering ink to a small ball valve in the tip of the pen that rotates and spreads the ink. Felt tips, introduced in the early 1960s, use a wicking action to deliver the ink. The tips tend to wear quickly, causing a myriad of colors that are highly resistant to water and solvents. This is a desirable feature for creating permanent writing, but it complicates forensic analysis since it is often necessary to extract the ink before analysis. The more permanent the ink, the more difficult it is to extract. Inks and related materials are also components of items such as typewriter ribbons, dot matrix printer ribbons, inkjet printers, copiers, and laser printers. Consequently, ink analysis can be a part of any questioned document case.

In 1968 the Bureau of Alcohol, Tobacco, and Firearms (ATF, now the Bureau of Alcohol, Tobacco, Firearms and Explosives) created a national repository for inks. In 1985 the collection was transferred to the United States Secret Service forensic laboratory where it currently resides. The collection includes several thousand ink samples. The primary use of the collection is for dating documents and related determinations. A voluntary taggant program was also initiated in the 1970s in which manufacturers would add different tagging compounds to ink every year. If an ink sample is found to contain a taggant, the examiner knows exactly in what year the ink was produced. If a document that was supposedly written in 1935 was created using an ink incorporating a taggant produced in 1975, the document cannot be authentic.

Dating of inks is particularly important in fraud and forgery cases in which an original document is altered at a later date using a different writing instrument and ink. If the analyst can prove the older document has been altered by the addition of newer ink, this is strong evidence of fraud. A simple example would be a case of a document purportedly

Paper in a printing press in which the paper moving through the rollers is just one way paper can be marked. *(Shutterstock)*

written in 1910 but found to contain ballpoint pen ink. Since the ballpoint pen was not invented until the middle of the century, the document is either a forgery or has been altered.

The type of paper used to create a document can also provide clues. Paper is made from wood pulp, resins and binders, bleaching agents and colorants, and cotton fiber. In general, the finer the paper, the higher its cotton content; premium papers are sometimes referred to as containing cotton rag. Other distinctive types of paper include thermal paper, used in older FAX machines and in some cash registers. This paper is thin, shiny, and the printing tends to fade over time. Forensic document examiners must be familiar with the many types of paper available and their most common uses.

Paper evidence can consist of anything from cash register receipts to index cards to fine writing papers. Some companies place a watermark on their paper, which is a physical indentation, created by thinning of the fiber content in certain areas of the paper. A watermark is an impression that is pressed into the paper when it is still moist, thinning that area and leaving a distinctive pattern that can be viewed when the

paper is held up to the light. If paper has a watermark, it can be help-ful in determining what company made the paper and when. Other markings can be left in the paper during manufacturing. Typically, the raw ingredients in paper are mixed in slurry that is dried on frames or rollers. This physical contact can leave impressions, striations, and other distinctive marks. Similarly, tools used to cut the paper may create markings and patterns.

Document examiners examine class characteristics such as paper thickness, watermark if present, and fluorescence created by dyes, bleaches, and other chemical additives. As with ink and pencil evalua-tions, paper is not unique. However, paper type can be useful in dating a document or to determine if separate paper samples are similar or dissimilar. For example, if a three-page will written in 1955 is altered by the addition of a forged page added in 2002, the papers will be dissimilar, and that is sufficient evidence to prove that a forgery has occurred. In some cases paper can be used for a physical match to prove a common source. For example, if a torn page from a docu-ment is found in one place and the torn corner recovered in another, a physical match of the two pieces proves that they were once part of the same document.

ART FORGERY

Art forgery shares some characteristics with document forgery but has its own unique aspects. In document forgery it is usually not the docu-ment itself that is valuable, but what the document causes to happen. For example, forging a check does not make the check itself valuable. Instead, it is the cash that can be obtained for the check that is the issue and the concern. In the case of art forgery, it is the piece of art that is of concern. Monetary value is attached to art based on when it was made, who created it, and how it is judged by critics and collectors. The most frequent question regarding forged art then is "is it genuine?" Often who created the forgery is less important than whether it was forged or not in the first place.

The second important point about art forgery is that although detecting it requires forensic skills and methods, often the issue does not involve the legal system. When a forged check is cashed, that is a

crime. When art is forged, it may or may not be a crime, depending on the circumstances.

Art forgery has a long history. Egyptian and Greek art was traded around the Mediterranean area in about 400 B.C.E. and increased as the Roman Empire spread. The Romans were fond of Greek statues, and the demand was so great that copy shops sprang up in Rome in about 100 B.C.E. As Rome began to decline in 300 C.E., so did art trafficking.

Western art revived slowly in the Middle Ages and was associated with the Catholic Church. Beautiful art was created during this period, but art trading did not flourish until about 1400, when wealthier people sought art for their homes and private collections. Soon Renaissance artists such as Michelangelo (Michelangelo Buonarroti, 1475–1564) and Leonardo da Vinci (1452–1519) were producing magnificent art that further encouraged the art trade. Artists copied works for practice and to learn the techniques of the masters. Not all copies were educational exercises, and forgery became more common.

During the 1700s, European royalty became active art collectors, further increasing demand for art and encouraging forgers. Two famous English auction houses were launched in that century, Sotheby's (1744) and Christie's (1766), which still auction art and collectibles from their London offices. Art museums appeared in European cities and were well established by the 1800s. It was also during this period that fake and forged art became a more pressing problem. By the 1850s recognized art experts were being called on by collectors and museums to help separate copies and forgeries from genuine original works of art. Sculptures as well as paintings received increasing scrutiny. Those who could authenticate art were suddenly sought to act as the forensic document examiners of their time.

One of the more famous modern art forgers was a Dutchman named Han van Meegeren (1889–1947). He is best known for his forged paintings passed off as the work of an earlier Dutch artist, Johannes Vermeer (1632–75). During his trial in 1947, van Meegeren said that his motive was to embarrass critics of his own work, which was never well received. Since van Meegeren painted in the 1930s, one of his challenges was to make modern paint appear as if it had come from the 1600s. Oil paint can take decades to dry, but van Meegeren learned that by mixing his paints with a quicker drying substance and by baking the canvas, he

could make it look much older than it was. The most famous Vermeer forgery was entitled *Christ and the Disciples at Emmaus,* which was erroneously identified by an art expert as a genuine Vermeer in 1937. This was an interesting case in that the forgery was not a copy of an existing painting, but the creation of a new one falsely attributed to an earlier master. Van Meegeren used techniques that were meant to create a painting that looked like a genuine Vermeer painting even though Vermeer never painted one like it. Van Meegeren may have intended to admit to

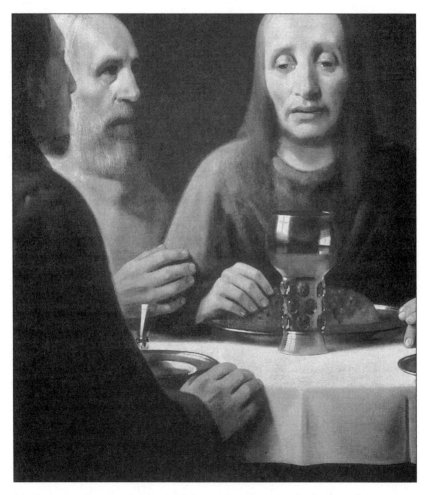

The Supper at Emmaus (1940–41) by van Meegeren, in which the style is meant to imitate Vermeer *(Art Resource)*

making the forgery just to embarrass the critics, but the painting sold for the equivalent of millions of dollars. As a result, van Meegeren turned his efforts toward producing more forged paintings including a fake Vermeer called *Christ and the Adulteress.*

Van Meegeren's downfall came toward the end of World War II. In 1943 he sold *Christ and the Adulteress* to Nazi field marshal Hermann Goering. The price he demanded and received was the return of 200 Dutch paintings the Nazis had stolen from Holland. The forgery was revealed in 1945, and van Meegeren faced trial in postwar Holland as a collaborator for selling forged Dutch art to the enemy. That charge was dropped since by selling the fake, he rescued plundered Dutch art from the Nazis. He was convicted of forgery and served one year in prison. He died of a heart attack while serving his sentence. His forgeries earned him the equivalent of several million dollars.

Art forgery continues to be a problem. Thomas Hoving, who was once the director of the New York Metropolitan Museum of Art, recently estimated that nearly 40 percent of the art on the market are forgeries. Forgers have been known to forge not only paintings, but people, creating libraries of paintings attributed to artists who never actually existed. Recently a forgery ring even went so far as to try to plant fake records of authenticity for forged paintings. As a result, assuring the authenticity of pieces of art has become a large and important segment of the artistic community, including museums, galleries, and collectors. Increasingly, art authentication requires knowledge of art, history, and science.

2

The Scientific Approach

For each method of forgery, there are scientific countermeasures to combat and detect it. The scientific tools range from simple inspection to sophisticated instrumentation. The most versatile technique remains the microscope, but in a variety of modern forms and extensions. When a document or piece of art is examined scientifically, the investigator must balance the need to obtain data against the potential damage that could be done to the evidence. As a result, nondestructive techniques such as visual examination are favored, but destructive methods are sometimes required. The only constant is variety; each case an examiner receives is unique, and each case will be approached differently based on what the evidence is, what information the examiner is asked to provide, and what procedures that examiner has available. Forensic document examiners employ physical tests and methods, visual methods and microscopy, and chemical methods of analysis.

Physical tests are among the simplest used in forensic document examination, but being simple does not mean that the tests are not powerful. Suppose that a ransom note is written on a piece of paper in a yellow legal pad. The criminal writes the note and then tears the paper out,

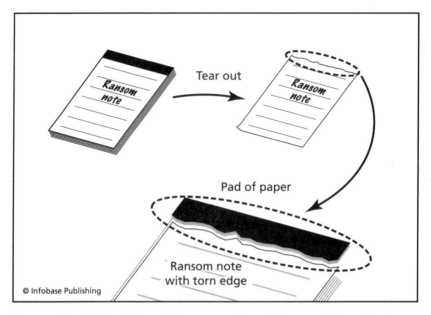

An example of a physical match between a piece of paper and the tablet from which it was torn

leaving a ragged edge behind in the tablet. It may be possible to link the ransom note to that legal pad (and to no other pad in the world) simply by seeing if the torn edge of the ransom note matches the torn edge on the legal pad. This is called a physical match, and it is conclusive. The document examiner does not have to do any other tests to confirm that the note came from that pad. Other questions may arise, such as when the note was written, but where the note came from is certain.

Other forms of physical tests are useful for classification and for eliminating possible sources. Measuring the dimensions of paper and its thickness is one example of a simple physical test. If the paper in question is too thick to match paper from a known source, no further testing is needed. Beyond these types of tests, most physical tests can be grouped with visual testing and examination. Microscopy is an extension of visual examination, but with advances in skill coupled with new instrumentation, microscopy also has elements of chemical testing. Finally, chemical methods of document analysis span simple chemical tests in which samples are treated, tested, or analyzed using modern analytical instrumentation.

VISUAL EXAMINATION AND MICROSCOPY

Visual inspection and examination was the first method used by forensic document examiners, and it remains vital to their work. For example, a document examiner is using visual examination when he or she studies handwriting and compares it to samples. Photographing and studying samples under different lighting conditions is another form of visual examination, as is making measurements on handwriting such as height of letters, spacing, and slant angles. Document examiners frequently study inks and papers, using ultraviolet and infrared light because different inks and papers respond differently under these kinds of illumination. When exposed to ultraviolet light (also called black light), some inks and papers will glow or fluoresce, while others will not. Visual examination is particularly valuable because it is nondestructive; however on occasion, samples have to be taken from a larger item. The sample is usually tiny, and any damage is difficult to detect, but in the cases of rare and precious art, any damage is serious.

Microscopic examination (microscopy) is a powerful extension of visual examination. For example, paint pigments and chemical crystals can be identified using specialized microscopic techniques. All optical microscopes are based on magnification that occurs when light passes through a specialized lens. The simplest design is that of a magnifying glass. Lenses can produce two different kinds of images. A real image is one that can be projected onto a screen (like a motion picture) or onto the retina of the person looking at it. The second type of image is a virtual image, which is what a magnifying glass produces. The virtual image is not physically real and can be seen only when looking through the lens. In the figure, the view is looking at a small fiber, about 25 millimeters (mm) in length, through a magnifying glass that is 4X, meaning that the image seen is four times larger than the object itself. The virtual image that the viewer sees through the magnifying glass appears to be about 100 mm long. Magnifying glasses, also called hand lenses, are limited to a maximum of about 20X. This reason is practical: As the magnifying power of a lens increases, so does the curvature of the lens. As this curve becomes sharper and narrower, the area that can be viewed becomes smaller. For many forensic examinations, 10–20X is sufficient.

A compound microscope, also called a biological microscope, builds on this design by using two lenses in a series, as shown in the figure.

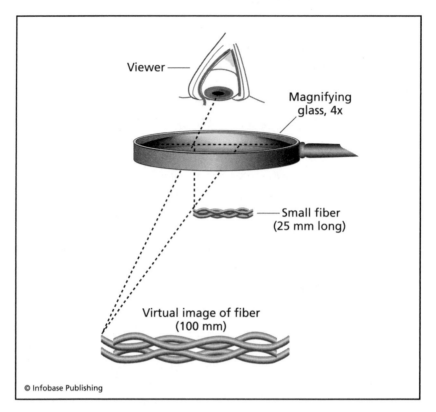

A magnifying glass in which a single lens creates the magnified "virtual" image of the fiber

The sample is illuminated by either transmitted (through the sample) or reflected light. The method of illumination depends on the type of sample and is particularly important when photos are taken or comparisons are required. In either case, the light passes through the objective lens that is closest to the sample. This lens creates a real image that is projected to the ocular lens in the eyepiece. Like a magnifying glass, the ocular lens creates a virtual image, but the virtual image is not of the object but rather of the real image created by the objective lens. The resulting virtual image seen by the viewer is magnified twice, once by each lens. The total magnification is the sum of the magnification power of each individual lens. In this example, the sample is a tiny 1 mm spec that is first magnified and projected as an image that is about 20 mm by the 20X objective lens. This 20 mm image is magnified again by the 5X

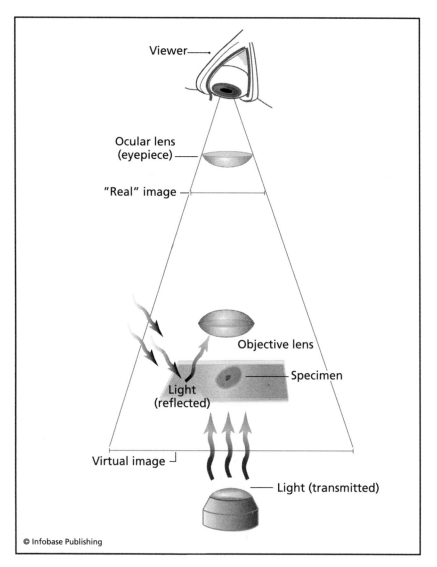

Viewer

Ocular lens
(eyepiece)

"Real" image

Objective lens

Specimen

Light
(reflected)

Virtual image

Light (transmitted)

© Infobase Publishing

A simple microscope consists of two lenses in series. These microscopes are often called biological or compound microscopes.

ocular to create a virtual image that appears to be 100 mm, a total magnification of 20 × 5 or 100X. Biological microscopes can be monocular (one eyepiece) or binocular (two). As with a magnifying glass, there are constraints to a compound microscope. Although high magnification is possible (800X), increasing magnification comes at a cost. Like the

magnifying glass, the higher the magnification, the smaller the field of view. Second, as magnification increases, the depth of focus (how deep into a sample the focus remains sharp) decreases. Typically, the resolving power of a microscope is defined by the symbol NA (numerical aperture), the value of which is printed on the objective. Most microscopic work in the area of fakes and forgeries requires relatively low magnification of between 10 to 400X.

Another common microscope used in document examination is the stereomicroscope, also called the stereoscopic binocular microscope or the stereobinocular microscope. Unlike the compound microscope, where the eyepiece can be monocular or binocular, the stereoscope requires two eyepieces to create a three-dimensional image of the object. A stereomicroscope is not a high-magnification device and is used for processes such as preliminary examinations and sorting of particulates. Much of the examination of questioned documents can be accomplished using a stereomicroscope or something similar.

The polarizing light microscope (PLM) and variants is perhaps the most versatile microscope used in forensic science and in the investigation of fakes and forgeries. Originally designed for use in geology and mineral identification (a petrographic microscope), polarizing microscopes are used in all manner of trace evidence analysis, including fibers, soils, hair, and paint. The key components of a polarizing light microscope are two polarizing elements or filters, one situated below and one above the sample; a compensator slot; a Bertrand lens; and a round rotating stage. The microscope works essentially by illuminating a sample placed on the stage with light that is propagating parallel or perpendicular to that sample. By rotating the stage or the filters, different patterns of light and color will be observed. PLM can be used to identify pigments and paint formulations and can provide information on composition of papers.

Microscopy is central to forensic document examination. Recent advances in instrumentation have extended the power of microscopy into the realm of chemical testing. In particular, it is now possible to combine microscopes to instrumentation that can provide a chemical analysis of the sample at the point where the microscope is focused. This marriage of microscopy and spectrophotometry (spectrometry) has been extraordinarily useful in forensic document examination.

SPECTROPHOTOMETRY AND MICROSPECTROPHOTOMETRY

Spectrometry is the study of the interaction of electromagnetic energy with matter. Colorimetry is the simplest form of spectrometry and studies how visible light interacts with matter. Colorimeters were among the first chemical instruments built, and forms of colorimetery still are routinely used in forensic document examination. Spectrometry is not limited to the visible range; any part of the electromagnetic spectrum can be employed.

All spectrometers consist of an energy (light) source, a device to filter the source energy and select the wavelength(s) of interest, a device or method to hold the sample, and a detector system that converts electromagnetic energy (light) to a measurable electrical current. UV spectroscopy probes the chemical bonding structure of organic compounds. X-ray

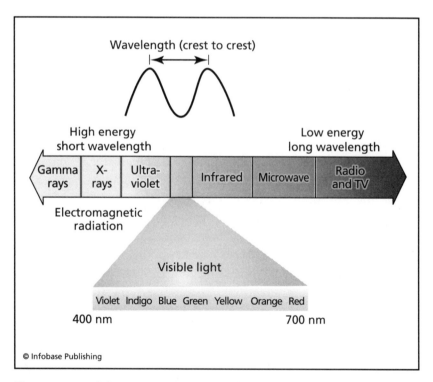

© Infobase Publishing

The spectrum of electromagnetic energy, where energy with a wavelength of between 400 and 700 nm is perceived by the eye as color

A microscope combined with a colorimeter, an example of a microspectrophotometer *(Craic Technologies)*

spectroscopy is used to identify elements and to probe the structure of crystals. Infrared spectroscopy is a powerful tool for identification of specific organic compounds. Spectroscopy in the radio range is the basis of a technique called nuclear magnetic resonance (NMR). It is also the basis of magnetic resonance imaging (MRI), which is used extensively in medical imaging.

A number of spectrophotometric techniques are based not on the absorption of energy but on its emission. Inductively coupled atomic emission spectroscopy (ICP-AES) relies on the emission of characteristic wavelengths of light for elemental analysis. Fluorescence methods exploit the absorption of energy, typically in the ultraviolet range, to produce emissions that reveal information about the element or compound. Examples include X-ray fluorescence (XRF) and spectrofluorometry. When elemental analysis of inks and paints is needed, these techniques are often used.

Different forms of spectrophotometry and spectrophotometric instruments are designed to manipulate different ranges of electromagnetic energy across the spectrum. Microscopy is based on manipulation of visible light. It is not surprising that microscopy and spectroscopy have been linked to form a new class of instruments called microspectrophotometers. Since the analysis of fakes and forgeries relies heavily on the analysis of color, microspectrophotometers that operate in the visible

range are especially valuable. These instruments can reveal the color of single pigment grains for example, or distinguish between two different types of paints in a painting. The science of color itself will be discussed in detail in the next chapter.

Another useful microspectrometer in document examination operates in the infrared (IR) region of the spectrum. IR micro spectrophotometers do not detect or measure color, but they can be useful for identifying the chemical composition of paints, dyes, and fibers. For very high magnification, a microscope that uses electrons called a scanning electron microscope (SEM) can be used. An SEM instrument achieves high magnification up to 1,000,000X (magnification by a factor of a million). SEM also has high depth-of-field, meaning that a large portion or depth of the image remains in focus no matter how high the magnification. This contrasts with traditional light microscopy, where the higher the magnification, the shallower the depth of focus.

A simple schematic of an SEM system is shown in the figure. Inside of a vacuum chamber, an electron gun aims a stream of electrons at a sample, which results in many interesting interactions. The emission of scattered and secondary electrons creates the image that the operator can see, but the image is in black and white. On the sample's surface, elements with higher atomic numbers will scatter more incident electrons and appear brighter than elements of lower atomic numbers. This difference will be discernible in the final image. Secondary electrons, which are actually emitted from the sample rather than scattered, are used to obtain information about surface features (topography). To generate an image, the electron beam is moved over the surface, scanning it as the backscattered and secondary electrons are collected. The image is a display that shows the relative intensity of the electrons collected at a given location. Older systems used cathode ray tubes (CRTs, similar to older televisions and to CRT computer monitors) to display the image, while newer systems typically incorporate some type of digital imaging. Since the signal is related only to electron detection and not to the detection of light as in traditional microscopy, the image is not colored. However, coloring (called false coloring) can be added to improve the visualization.

Another advantage of SEM is the ability to determine the composition of the sample. Metals such as titanium and iron are important

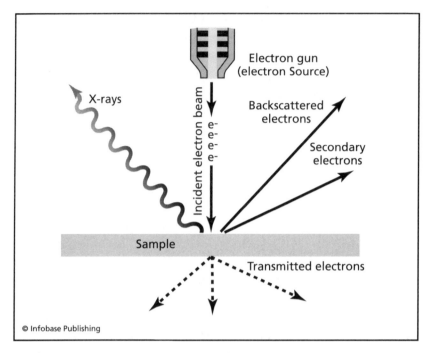

© Infobase Publishing

An overview of how electron microscopy operates where the image is created when the backscattered electrons are displayed on a screen

components of pigments, paints, and inks. To detect these metals, some form of elemental analysis is required. Because of the design of the SEM, this can be accomplished when the sample is being imaged, as shown in the figure above. For example, when X-rays interact with the electrons surrounding an atomic nucleus, they can cause inner shell electrons to be ejected from the atom. This creates instability that is remedied when an electron from an outer shell moves in to fill the vacancy. When an electron falls into an empty orbital, it must release energy, and does so in the form of an X-ray. The emitted X-ray is of a longer wavelength (lower energy) than the original incident X-ray. If a filling electron comes from one shell away, the process is referred to an α (alpha) transition; from two shells away β (beta) transition; and from three shells, γ (gamma) transition. Because more than one electron can be ejected and more than one electron can change shells during the refilling process, each atom can give off more than one wavelength of radiation. The pattern of emitted X-rays is characteristic of a given element. For example, for

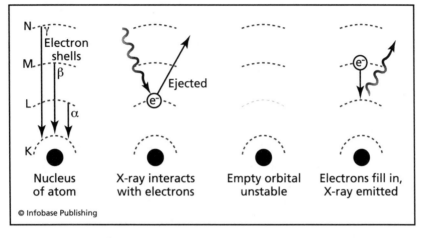

How X-rays cause electrons to move in an atom

the element lead (Pb), a common ingredient in paint pigments, the electron transitions are labeled $K_{\alpha 1}$, $K_{\alpha 2}$, $L_{\beta 2}$, $L_{\alpha 1}$, and $L_{\beta 1}$. The letter corresponds to the shell where the falling electron originated. Within each shell, additional sublevels exist, leading to the number designation. XRF can be used to identify the elements present and their relative concentrations since the intensity of emitted radiation will be proportional to the amount of the element present. It is not, however, considered to be the ideal choice for the identification of trace elements present at levels below 0.001 percent.

OTHER ELEMENTAL ANALYSIS TECHNIQUES

There are other methods of elemental analysis used to uncover fakes and forgeries. One family of elemental analysis techniques is based on inductively coupled plasma (ICP). In an ICP torch, gaseous argon (Ar) is ionized by a Tesla coil to form Ar^+ and free electrons. These ions are accelerated and confined in a stable magnetic field. The resulting high-energy collisions generate tremendous heat in the range of approximately 18,500°F (10,300°C). Under these extreme conditions in the plasma, most chemical compounds are broken apart to atoms and ions. Plasma is considered to be a separate state of matter in addition to solid, liquid, and gas. It consists of free electrons (electrons not associated with a specific atom), atoms, and ions and is characterized by an intense glow

An example of images obtained using SEM. This micrograph shows the structural features of four different gel pen inks. *(Reproduced with permission from Wilson, J. D., et al. "Differentiation of Black Gel Inks Using Optical and Chemical Techniques." Journal of Forensic Sciences 49 (2004): 364–370. © 2004, ASTM International)*

reminiscent of a flame. However, plasmas emit harmful ultraviolet radiation, and so the user or viewer only sees the plasma through a thick layer of protective glass. Plasmas are also found in the Sun.

Two ICP instrumental techniques are used in forensic science. ICP-AES is a form of emission spectroscopy (*atomic emission spectroscopy*) in which the heat of the plasma is not only sufficient to atomize the sample, but also to place many of the atoms into the "excited state." In such a state an atom emits characteristic wavelengths of light in the vis-

ible and ultraviolet ranges that can be used to identify specific elements in the sample and also to determine their concentrations. The second forensic application of ICP is in mass spectrometry (ICP-MS) in which the plasma is the source of elemental ions. These ions are directed into the mass spectrometer, where they are separated, detected, and can be quantitated based on their masses. ICP-MS can detect isotopes of ele-

Science and Art

Science meets art in many places, not just in detection of forgery. The National Gallery of Art, located in Washington, D.C., contains one of the largest art collections in the United States. Its curators and scientists use scientific techniques to detect forgery and to protect, preserve, and restore works of art. The staff was able to show a group of statues that were thought to have been linked to Italy during the Renaissance. The statues were supposedly made of bronze, a metal alloy consisting of copper and tin. The scientists used X-ray fluorescence and atomic absorption spectroscopy to show that the statues were made of brass, which is an alloy of copper and zinc. While the two alloys

Art restorer at work on Rousseau's *Boy on the Rocks* in the National Gallery of Art, Washington, D.C. *(AP)*

look nearly identical, their chemical composition is quite different and easily detected with these instruments.

Other observations led the investigators to conclude that the statues were most likely made sometime around 1900. The statues appeared to have been produced as a batch using the same technique for each. Genuine Renaissance pieces would likely be much more variable.

ments (such as carbon-14, an isotope used in archaeological dating) and multiple elements simultaneously. The instrument can also be used to analyze solids directly, avoiding the need for complex acid digestions and sample preparation.

For the forensic document examiner, often very small samples must be analyzed. Small samples are not ideal for ICP-AES or ICP-MS where relatively large volumes of sample are needed. Fortunately, there is an alternative method of sample introduction that is showing promise in forensic document work. In a technique called laser ablation, lasers are used to vaporize small portions of a sample surface, and the vapors are then directed into the plasma. The ICP techniques are all destructive techniques since a small portion of the sample must be dissolved before it is introduced into the instrument. Thus, the examiner can direct the laser at a small spot on a document, engage the laser, and obtain an analysis without destroying anything other than the spot itself.

SCIENTIFIC METHODS AND PAPER

Like other forms of physical evidence, paper can be subjected to physical and chemical analysis. Many of the tools are the same as introduced above, and they include physical, visual, and chemical methods. Physical analysis includes measuring dimensions and thickness, studying color, texture, fiber types, and watermarks. Databases of watermarks are sometimes useful for dating a document based on when the manufacturer first used the watermark. The fibers in paper can also be studied microscopically to determine class characteristics such as wood or cotton and their condition, which in turn can reveal information about how the pulping process was done. Pulping is the process of mixing together the raw materials including the wood and cotton fibers with solvents and other materials to form a paste. This paste is then spread to the appropriate thickness and dried. Chemical analysis of paper can include study of the dyes, coatings, glues, and binders, as well as analysis of trace elements found in the paper.

Another kind of evidence associated with paper is indented writing. Writing with a pen or pencil, a person pushes down on the paper. If the paper being written on has more paper below, such as in a writing pad or a stack of notepaper, this pressure also pushes into the next few sheets. The harder someone presses, the deeper the indentations in the paper below. Indented writing is important evidence because it links a piece

Indented Writing and a Physical Match

Some of the most valuable tests in document examination are simple. To get an idea of this, find a notepad of paper, a pen, a flashlight, and a pencil. Take the pen and write something on the pad, pressing down fairly hard. Press hard and the writing pattern will transfer onto the next page. Then remove the top sheet by tearing it out of the pad. One can see how the torn edge of the paper lines up with the pad; this is called a physical match.

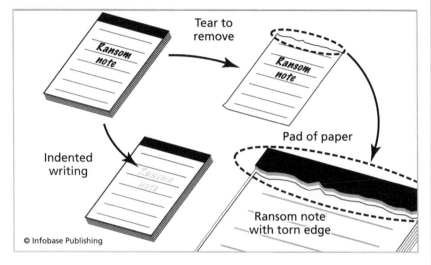

Tear to remove

Pad of paper

Indented writing

Ransom note with torn edge

© Infobase Publishing

Ways that paper can provide clues. Once the ransom note is torn from the pad, the paper will fit back into the pad like a piece of a puzzle. Sheets below the original note will have indented writing.

Next, darken the lights and hold the flashlight so that it lies straight above the paper. Move the flashlight around slowly so that the light hits the paper at different angles. Find an angle where the indented writing is easier to see. This is called oblique lighting, and it is a technique widely used by forensic document examiners. Another method is to rub the pencil across the page. The pattern of the writing may appear depending on how hard the pen was pressed when writing on the top page. This procedure appears in many movies, and although it works, forensic scientists do not use it because it ruins the evidence.

Despite being one of the most used materials of the modern world, forensic document examiners can still find useful information by testing and analyzing paper on a roller. *(Landov)*

of paper to a specific pad of paper just as a tearing pattern would. The scientific tools used for analyzing indented writing are different from others used in forensic document examination and described so far.

One device used to visualize indented writing is an electrostatic detection apparatus (ESDA), which takes advantage of the same technology used in copying machines and laser printers. A sheet of thin plastic is placed over the paper that has the suspected indented writing, and both are placed in a vacuum chamber. A charge of static electricity is imparted to the plastic and then toner powder is applied to the surface of the plastic. An image of the indented writing will be created on the plastic, with the added advantage that the original paper is not altered or damaged.

3

Dyes and Pigments;
Inks and Paints

The chemicals in paint and ink that are responsible for producing colors are known as pigments or dyes. Pigments are composed of tiny particles that are suspended in the solvent (also called the vehicle) much as fine dirt is suspended in water. When ink or paint is placed on paper, the solvent dries, leaving the colored pigments on the surface. Dyes are not particulates, and rather than being suspended in the solvent, dyes dissolve in it. Food coloring is a dye, not a pigment, because it is a liquid without solid particles. When the solution containing a dye is placed on paper, the dye will penetrate as far as the solvent does, leaving the color inside the surface. Most pigments are inorganic materials such as zinc oxide (ZnO), which is used in sunscreen creams. Rust (Fe_2O_3) in water is a pigment. Most dyes are organic compounds that can be natural or synthetic. Carotene, the structure of which is shown in the figure, gives carrots their orange color. Like most dyes, carotene is a large organic molecule.

Dyes and pigments are colorants, meaning that they impart color to whatever in or on which they are found. Before further discussion of dyes and pigments, however, it is necessary to discuss color from the

The chemical structure of a dye. The long chain of alternating double bonds is characteristic of highly colored compounds.

scientific and forensic point of view. In the world of forensic document examination, color is critical. People, however, see color differently and therefore subjectively. One person may describe a color as stop-sign red, while another would describe the same color as fire-engine red. Much of the variation comes from the way in which people perceive color. For the forensic document examiner, it is critical to be able to describe color scientifically, to understand what makes something colored, and how best to describe color objectively.

THE SCIENTIFIC VIEW OF COLOR

The ability to distinguish colors is critical in the investigation of fake art and forgery, even when the color is black. Paper is the substrate for the inks and paints that are used to create documents, drawings, money, and art. Colorants such as inks and paints are placed on the paper or the canvas to impart color. The process of perceiving color is complex and differs from person to person. For example, if 10 people are given a variety of watercolor paints and paper and asked to paint a red ball, the color each person selects will likely be different, even though all are considered red. For the forensic scientist, color must be understood and defined such that the difference in the reds can be described and presented accurately. Walk into any office supply store, and there will most likely be a dozen red pens, each with different characteristics and different colors of red. Differentiating between pens may be critically important in determining if a specific pen could have been used to write a specific document.

Humans perceive a color when electromagnetic radiation from a narrow region of the electromagnetic spectrum reaches the eye. Visible light is part of a spectrum of energy that includes radio, television, micro-

waves, and X-rays. The energy travels in waves, much like how waves are created in a pond when a rock is dropped into it. The waves are defined by their wavelength and by their frequency. The higher the energy level is, the higher the frequency and the shorter the wavelength. Visible light has wavelengths ranging from approximately 400 nanometers (one nm = one one-billionth of a meter) to 700 nm. Different colors have different wavelengths. The most energetic visible light is perceived as blue, the least energetic as red, and the median as green. The spectrum of colors is abbreviated as ROY G BIV, an acronym for red-orange-yellow-green-blue-indigo-violet. The illusion of white light occurs when all colors are mixed together, such as light coming from a light bulb or the sun.

Color arises in two general ways. Assume that a small amount of blue food coloring (a dye) is placed in a test tube of water and that a light is shined through it. The dye absorbs all wavelengths of light except those in the blue range. Since only the blue light emerges from the test tube,

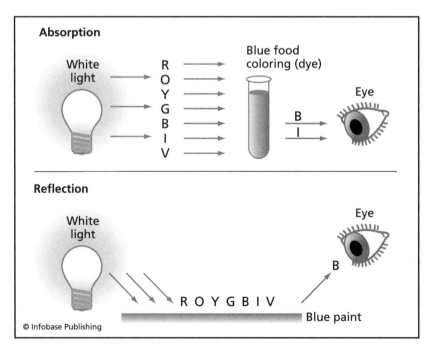

Perceived color created by absorption and by reflection. What reaches the eye is the original white light containing all colors minus the colors absorbed or reflected.

it appears blue to the person looking through the test tube. The blue is left because the other wavelengths have been removed when the water in the test tube absorbed it. This process is called absorption. Color is perceived based on what the sample media absorbs or subtracts from white light.

Of greater interest in forensic document examination is the other possibility. For example, if blue paint is placed in a layer on canvas, it also absorbs all other wavelengths but reflects light in the blue range. Since the blue is all that is reflected, that is what the viewer perceives. The color is due to selective reflectance, and this is the way inks produce color. By mixing different pigments and dyes at different combinations, an infinite number of selective reflectance combinations are possible, leading to a nearly infinite number of possible colors that can be created. If all the visible light is absorbed, black is seen. The writing on this page appears black because the ink used to print these letters absorbs all wavelengths of visible light. Another way to view this is that the ink

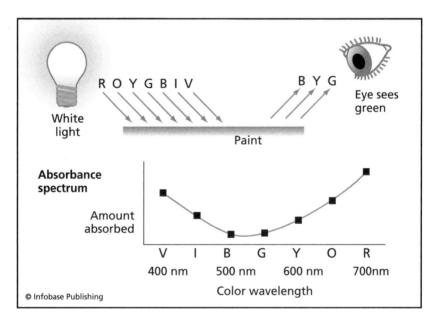

© Infobase Publishing

A spectrum of energy that appears green to the eye. The paint on the surface absorbs the colors on either side of green such that the viewer perceives the reflected color as green. This same green can be expressed in the spectrum, which shows absorbance as a function of wavelength.

blocks the white surface of the paper from reflecting, so anywhere that there is ink, such as in the pattern of the letter, no light is reflected and the spot appears dark.

The two most common ink colors are black and blue, both of which are formulated using mixtures of dyes and pigments. Ink from two different pens might look identical even if they are made of different mixtures. This is especially true of black inks, which have many different formulations. For this reason, it is critical that color can be described independent of viewer's interpretation. It is also important to separate the individual components of an ink or a paint and the dyes or pigments of which they are composed.

Color can be measured instrumentally using a colorimeter, which produces a plot of the energy that is absorbed or emitted as a function of the wavelength of light. The plot, called a spectrum, records how much light at a given wavelength (color) is absorbed. Think about a surface that is painted green. If the eye detects green, that means that green, yellow, and blue are reaching the eye but the other colors or wavelengths are absorbed by the paint surface. The amount that is absorbed can be plotted as shown in the figure. The red and orange lights are absorbed by the paint and never reach the eye; the same is true for the indigo and violet light. What is absorbed is not seen. Thousands of different shades are made by altering the amount and type of colors that are absorbed. Adding a red dye to a green dye produces some shade of purple that can be darkened by adding an indigo dye, and so on. For the scientist who is studying color, the absorbance spectrum is the best description of color and the best tool for comparing colors.

Using instrumentation to plot energy absorbencies in the visible range is called colorimetery. Because the eye can be used as a detector, colorimetery was one of the first forms of spectrophotometry developed. In modern instruments, instrumental detectors replace the eye with devices that convert light to electrical current that can be displayed or manipulated further. To obtain a colorimetric scan of a material such as an ink line or paint chip, white light is shined on or through a sample and then directed by a series of mirrors onto a detector that responds to visible light. An electrical signal is generated that is then converted to instrumental readouts. A specialized instrument can be used in forensic document examination in which the reflected color is measured

and a spectrum produced. For inks and paints, such instrumentation is invaluable.

INKS AND PAINTS

Inks and paints are colorants of primary interest to forensic document examiners. Both can contain dyes, pigments, or combinations, although paints are usually pigment-based. The general formula of inks and paints are similar. A solvent or mixture of solvents is used to dissolve or suspend the colorants to a surface. The difference between a dye and a pigment relates to solubility; the figure shows how this affects the way the colorant gives color to the surface. Other additives can be used to create a protective finish, prevent molding, create a shiny finish, or serve other purposed depending on use.

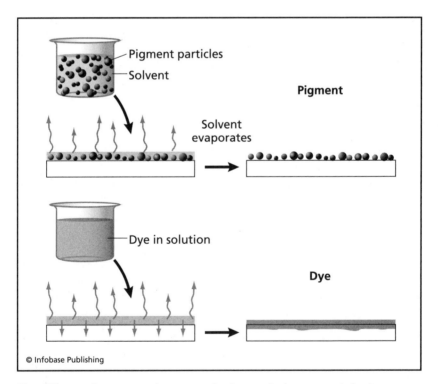

© Infobase Publishing

The difference between a pigment and a dye applied to paper. A dye is a solution that penetrates into the paper, while paint is a suspension of particles that adhere on top of the surface.

The oldest ink, called India ink but originally used in China, consists of carbon black (ground charcoal) suspended in water and containing adhesive gums and varnishes. Iron gallotannate inks contain inorganic colorants along with tannic acid and are used in fountain pens. Inks used in ballpoint pens contain synthetic dyes dissolved in organic solvents and additives to maintain a thick consistency. Gel pens contain synthetic dyes that are impregnated into gel. Like ink, paint can be thought of as a coating of coloring agents that are suspended or dissolved in a solvent containing other additives such as binders and drying agents. Pigments were at one time primarily compounds such as titanium dioxide (TiO_2, a white), Fe_2O_3 (rust), or compounds made up of cadmium, lead, and other metals. Because of their toxicity, many of these compounds have been replaced with organic pigments. Lead-based paint has been banned since the 1970s yet is still responsible for several child poisonings each year where old paint flakes off walls and is ingested accidentally.

Solvents employed in ink and paint formulations can be organic such as toluene, or water-based such as latex. Water-based paints can be cleaned with soap and water and are popular for home interiors. The solvent, whether water or organic, is referred to as the vehicle. Finally, polymers or materials capable of polymerization (called binders) are included and when dry, they form a protective coating over the pigments. Some forensic investigations focus on these components in addition to the dyes and pigments.

Many scientific tools are available to investigate inks and pigments. One simple tool is thin-layer chromatography (TLC), which is an effective method for separating the different dyes that are present in an ink such as blue or black. The process is illustrated in the figure. To perform TLC, ink samples are placed at the bottom of a plate that is coated with a thin layer of a powdery material. When the ink spot dries, the plate is then placed in a tank with a small amount of solvent. The ink spots start above the solvent level, but the solvent is drawn up the plate much as water is drawn up into a paper towel when the end is dipped in water. The solvent picks up components of the ink, and they interact with both the solvent and the powder. The more the ink components interact with the powder, the slower they move relative to the solvent. After a few minutes, the components that can be separated by this method will do so. Pigments, which are suspensions in a

solvent, will not move away from the original spot, called the origin. Pens that use the same inks will have the same band pattern under the same TLC conditions.

Finally, detecting forged writing can sometimes be achieved by looking not at the ink or the paper, but at the writing instrument. Some pens are ballpoint, some are fabric or felt-tipped, and some newer pens are based on a gel formulation. Even among the same family of pens, the shape of the tip can be quite different in that it produces unique line shapes, sizes, and patterns that are often detected under the microscope.

DATING INKS

Some of the issues that analysts often face when examining documents or similar evidence are the age of the document and whether the document was created at one time and altered at a later time. Art painted by Leonardo da Vinci would have to be created during his lifetime, for example. People who investigate art and art forgery study canvases, paint compositions, and varnishes to determine if they are authentic to the period in which they were painted. The paint must dry, which sounds obvious. Dry to the touch is different from dry in the chemical sense.

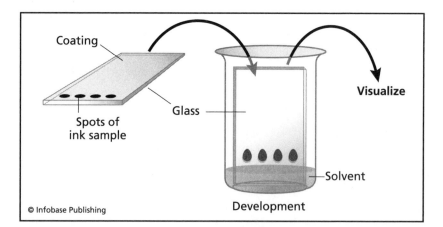

The process of thin-layer chromatography. Samples of ink are placed in small spots on a coated glass plate. After development, the components of the inks can be seen or visualized using infrared or ultraviolet illumination.

Thin-layer chromatography (TLC) of several black inks. The top frame is viewed in normal light, the bottom under infrared light. Sample 8 is a pigment-based ink and does not move in the solvent. *(Reproduced with permission from Wilson, J. D., et al. "Differentiation of Black Gel Inks Using Optical and Chemical Techniques." Journal of Forensic Sciences 49 (2004): 364– 370. © 2004, ASTM International)*

Paint is dry when all of the solvent used to carry the pigments is gone and the polymer coating has completely formed. This can take months or years, depending on the type of paint used. Art investigators can also study the painting to see if the materials have aged as would be expected for a painting that is nearly 600 years old. The ingredients in paint age, as anyone who has painted a porch or house knows. This aging is also called weathering, and much of it is caused by exposure to ultraviolet radiation (UV). This occurs even if the painting is kept indoors. Other factors that contribute to weathering are microorganisms, such as bacteria and mold, and moisture that slowly deteriorate the material. Old paints and paintings tend to crack and fade in a way that fresh paint does not, which is one of the most powerful tools available to art experts and art historians.

Ink ages just as paint ages, which can be useful to forensic document examiners. Inks, like paint, must dry, and this process can take

years. The degree of dryness can be estimated by extraction of the ink into different solvents. The drier the ink, the more difficult it will be to extract. Although reasonably successful, dryness tests require that the

Walter McCrone (1916–2002): A Leading Expert in Microscopy

Dr. McCrone is considered to be the best chemical microscopist of the 20th century. Born in Wilmington, Delaware, he was a chemist by training and obtained a B.S. degree and a PhD degree in chemistry from Cornell University. He moved on to Chicago, Illinois, and the Illinois Institute of Technology (IIT) in the 1940s, where he began to teach microscopy courses. In 1956 he left IIT to found the McCrone Research Institute (see the Web site at URL: www.mcri. org) where hundreds of microscopists and forensic scientists received training.

Dr. Walter McCrone *(McCrone Research Institute, Inc.)*

McCrone published and edited *The Microscope,* a journal that contained hundreds of articles in the fields of microscopy and microchemistry. Among his many awards was the Paul Kirk award, bestowed on him in 1984 by the Criminalistics section of the American Academy of Forensic Sciences. He also received the Analytical Chemistry Award from the American Chemical Society in 2000.

In the world of fakes and forgeries, McCrone is best known for showing that the Shroud of Turin, the purported burial cloth of Jesus Christ, is actually a painting. He also worked to uncover a fraudulent map called the Vinland Map. Both of these famous cases are described in detail in chapter 5.

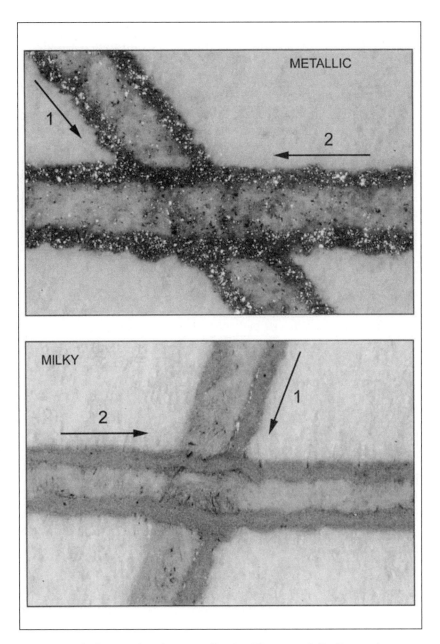

Two types of ink viewed under magnification. The arrow "1" indicates the line that was drawn first. *(Reproduced with permission from Wilson, J. D., et al. "Differentiation of Black Gel Inks Using Optical and Chemical Techniques." Journal of Forensic Sciences 49 (2004): 364–370. ©2004, ASTM International)*

examiner have a fresh sample of the ink that has been spread on a similar media and stored in a similar fashion as the questioned sample.

Dating of inks is particularly important in fraud and forgery cases in which an original document created on a given date is altered at a later date, using a different writing instrument and ink. If the analyst can prove the older document has been altered by the addition of newer ink, then that is strong evidence of fraud. A simple example would be a case of a document purportedly written in 1910 but found to contain ballpoint pen ink. Since the ballpoint pen was not invented until the middle of the century, the document is either a forgery or has been altered. Some inks also contain taggants that can be used to date it.

Since inks and paints are similar in many respects, scientists can use the similar techniques to analyze them. Simple microscopic examination is where many analyses begin. Paints are often applied in layers that can be seen with low magnification, and the pattern of layers is often all that is necessary to differentiate a genuine article from a forgery. Returning to the example of a painting by Leonardo da Vinci, the paint in areas of the canvas would be layered and would most likely include primers and coatings that a forger would not recognize. In addition, canvases are sometimes reused, so there could be evidence of earlier paint layers on a genuine Leonardo da Vinci painting that a forger could never re-create. A tiny paint chip could reveal the presence or absence of such layers.

The microscope is also used extensively to identify pigments. Walter McCrone, PhD (1916–2002), an expert in pigment and paint identification, was able to identify several forgeries. Microscopic examination of documents and inks can also be used to determine if an ink contains metallic components since many will sparkle like glitter. The picture also shows how a microscope can be used to detect the order in which lines were placed on paper. The photo shows two types of ink both from gel pens. One contains metallic particles that are clearly visible, while the other (called milky) does not have these features. In both photos, it is easy to see which line was applied first, and such information can be used to uncover forged signatures or later additions to documents by overwriting.

4

Detecting Document Forgery

Perhaps the type of forgery most people associate with forensic document examination is forged signatures. These do make up a large part of the forgery cases, but there are many other kinds of document forgery. Sometimes a person will alter a check, trying to obtain $500 from a check written for $5. A person writing a ransom note will try to disguise the handwriting to prevent it from being matched to him or her. One common trick is to write with the nonnatural hand, such as when a right-handed person uses the left hand. Other times, a person may try to remove something from a document by obliteration. Forensic document examiners have seen it all and have found ways to detect them.

SIGNATURES

To forge a signature successfully, it is necessary to reproduce the appearance of the signature and to do so with a smooth, continuous motion. To accomplish both of these tasks is nearly impossible. Consider the two most common methods of forging a signature. The first is to look

closely at it and attempt to re-create it carefully, moving slowly to follow the lines as closely as possible. This method is called drawing because, in effect, that is what the forger is doing. Pen strokes tend to be slow, deliberate and not necessarily in the same order in which the real signature was created. Several pen-lift points may show that the writer has gone back over sections to make them appear more authentic. The lines often show evidence of pauses and repeated small corrections that can be seen under low magnification.

Another approach of forging a signature is to trace it. This can be done by shining a bright light through the original or by using carbon paper. Evidence of tracing is usually detectable, again by speed of writing or by identification of faint tracing lines or indentations. Another technique is to trace a signature very lightly using pencil and then going over it with ink. This allows the forger to move the pen more rapidly, but the order of lines and other nuances will still differ from a genuine signature. There may be spots where pencil is still visible, and if the ink is IR transparent, it may even be possible to use different forms of lighting to reveal the lines below the inked signature. Even if the forger takes the time to erase any stray pencil lines, the act of erasing leaves signs on the paper.

One of the telltale signs of a tracing is that repeated tracings of one signature will be identical to one another. No one ever writes his or her signature exactly the same way twice in a row. The differences may be very small and subtle, but they are detectable to an expert. When a set of signatures is identical, a tracing or other method of duplication has probably been used.

In any handwriting analysis and comparison, the examiner works from a set of known writings. These can include collected writings that are known to have been written by either the suspect or the person whose writing has been forged. Examples of known writings include cancelled checks, lists, and notes. Exemplars are writings that are obtained after an investigation and are collected by police or the document examiner. Exemplars include copies of presented material that can be given in written form or dictated. The latter can be important, as often the police or the examiner will not want the suspect to know what writing has been forged. In a case of a forged will, a suspect would not be shown the will in question but rather would be requested to produce exemplars crafted

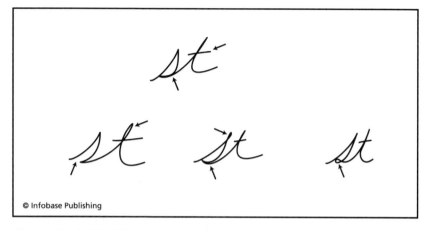

Class and individual characteristics in handwriting. Linking the *s* to the *t* and crossing the *t* are class characteristics of cursive writing. Individual characteristics are the loops and other variations as shown

to contain similar letter combinations, words, and phrases. Usually an exemplar will include several repetitions to determine normal variability, a key component in any type of handwriting comparison. Using the questioned writing and the known writings from the victim and the suspect, the examiner will study class characteristics and individual traits in an attempt to determine authorship.

Another important form of exemplar is writing that was done in the past, for example, old checks, credit-card receipts, school papers, and even shopping lists. The advantage of this type of writing is that the person usually creates the source without giving it much conscious thought. As a result, these sources are the best unbiased representations of a person's handwriting style. The disadvantage is that many such writings are not witnessed, and so it is hard to be absolutely certain that the person of interest wrote it. Ideally, the document examiner will have many exemplars from people who may have created a counterfeit writing.

The goal of scientific handwriting analysis is to either link a specific person to a specific writing or to exclude the person as a possible writer. It is easier to exclude than to include, but much depends on the writing samples and the exemplars that are available to the document examiner. The characteristics that an examiner uses to compare writing samples include class and individual characteristics such as angle, spacing, rela-

A Famous Case of Handwriting Analysis

The examination of questioned documents was established in Europe and the United States by the 1930s, but it took a famous case to bring it to the public's attention. Charles A. Lindbergh became a national and international hero in 1927 after flying the Atlantic Ocean alone in the *Spirit of St. Louis.* He later married Anne Morrow, and their first child, a son named Charles, Jr., was 20 months

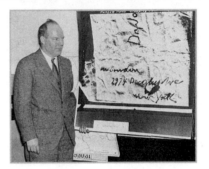

Albert D. Osborn testifying at the Lindbergh trial *(Corbis)*

old when he was kidnapped at about 9:30 P.M. on March 1, 1932. He was taken from his nursery which was located on the second floor of the Lindbergh's home in Hopewell, New Jersey. The kidnapper left a homemade ladder at the scene that would later provide critical evidence, but footprints also left were not properly documented or preserved. A ransom note, one of 14 that would be sent by the kidnapper, demanded $50,000 in ransom for the boy's safe return. Mailed notes all had postmarks from the New York City area.

The investigation by the New Jersey State Police was headed by Colonel Norman Schwarzkopf, father of the general who would later lead coalition forces to victory in the 1991 Gulf War. The case took many bizarre turns and became the subject of worldwide media frenzy. An elderly retired teacher named John Condon became the intermediary between Lindbergh and a man who called himself John. Eventually a ransom of $50,000 was paid, the majority of it in gold certificates, which were used as currency at the time. Serial numbers of the bills were recorded before the money was delivered.

Sadly, the body of the child was found one month later in the woods close to the Hopewell home. The cause of death was listed as a skull fracture, most likely the result of an accidental fall from the ladder during the kidnapping. However, given that a forensic pathologist or

medical examiner did not conduct the autopsy, that conclusion has been questioned. It is possible that the kidnapper killed the boy shortly after the abduction and dumped the body near the home. The kidnapper never communicated with the Lindberghs after the ransom was paid.

In 1933, President Franklin Roosevelt ordered that all gold certificates be exchanged for standard currency. Law enforcement agents working on the case hoped for a break, anticipating that the kidnapper would have to turn in a good portion of the ransom money, most of which had not yet surfaced. That which had been spent was all in the New York City area, allowing law enforcement to concentrate efforts there.

The break came in September 1934, when an exchange bank received a $20 gold certificate from a man who matched the description of the kidnapper. More important, a license plate number had been written on the bill, which was quickly traced to a truck belonging to Bruno Richard Hauptmann, who lived in the Bronx. He was arrested, and a subsequent search of his garage uncovered a gun and several thousand dollars of the ransom-money gold certificates. Hauptmann at first denied all knowledge of the money but soon changed his story, claiming that a friend had given him the money. The friend had returned previously to Germany and died there, making it impossible to investigate that claim.

During the time between the kidnapping and murder of the child and Hauptmann's arrest, forensic investigations were undertaken on the physical evidence, including the ransom notes, trace evidence, psychological and psychiatric studies, and—perhaps most damaging for Hauptmann—analysis of the ladder. Albert S. Osborn, a pioneer in the field of questioned documents, performed analysis of the handwriting found in the ransom notes and concluded that the handwriting was that of Hauptmann.

Arthur Koehler, a wood expert employed by the Forest Service, undertook a meticulous evaluation of the ladder, including the wood, construction techniques, and toolmarks found on the wood. Eventually, he

(continues)

(continued)

was able to trace the lumber used to a lumberyard and mill located in the Bronx. Marks made by planers on the wood in the ladder matched a planer at the yard. A search of the attic above Hauptmann's apartment revealed a missing floorboard. Nail holes and tree ring patterns from a rail of the ladder lined up perfectly where the floorboard had been. Furthermore, Koehler was able to demonstrate this at the trial to show how the planer marks from the ladder matched Hauptmann's planer. Hauptmann was convicted, and after a series of appeals and reviews, including one by the U.S. Supreme Court, he was executed on April 3, 1936.

tive sizes, order of pen strokes, line characteristics, letter styles, and even grammar and spelling. For example, a person who misspells the word *night* as *nite* will likely do it consistently in a handwritten document. People also tend to make the same grammatical mistakes and use the same phrases and words repeatedly. If the examiner has sufficient samples with which to work, sometimes the frequency of these features can help identify or exclude a person as a possible author of a document.

A document examiner will look for class characteristics and individual characteristics when evaluating handwritten documents. Examples of class characteristics of handwriting would be how a cursive *s* and *t* are connected and the crossing of the *t*. Individual characteristics would be how the *t* is crossed, how high it is, and extra loops or other strokes not essential to creating the letter. Other features would be the slant of the letters, how they are spaced, how they are connected, the relative height of letters, and when the pen is lifted. A person signing or writing a letter does all of this unconsciously and roughly the same every time. To duplicate all of these details is very difficult even for the best of forgers.

Finally, in cases of very old writing, the style of the lettering can be important. For example, look at the signatures on the Declaration of Independence. As was common in the late 18th century, the signatures were formal and fancy. They are also ornate but easy to read. Contrast

this to modern signatures, which tend to be much harder to read and without extraneous pen strokes and decoration. The style must be period authentic, a characteristic that will be seen again in the discussion of art forgeries.

DISGUISED WRITING

Another type of handwritten forgery is disguised writing. The person writing a document such as a bank-robbery demand or a ransom note will try to disguise the writing Similarly, if the person who receives the writing is likely to recognize the writing style, the writer may want to disguise it so that it cannot be easily recognized. A simple way to do this is to write with the opposite hand than is normal. Unless the writer is ambidextrous, the resulting writing typically has a scratchy, childlike appearance. Another approach is to use a different style than usual, such as using block print in place of script.

OBLITERATIONS AND ALTERATIONS

Sometimes forgers start with existing genuine documents and attempt to alter them for fraudulent purposes. A check written for $10 can be altered to read $100, avoiding the need for forging a signature on a bogus check. Adding a zero to the number is easy compared to altering the words *ten dollars and 00/100 cents.* Techniques that can be used to remove the writing are bleaching or actual physical removal by careful shaving of the paper's top layer. The newly exposed paper can then be altered as the forger desires. Opaque fluids can be placed over the writing as well. In some cases, a person scribbles over writing to blacken it out, which is a form of obliteration.

Many times the forensic document examiner can tell if a document has been altered by using different types of lighting or illumination. Consider a check that was written for $10 and then altered to $100. The forger will certainly use the same color of ink as the original check, for example, black ink. Black inks all look black, so the examiner will probably not be able to see a difference by visual examination alone. However, different types of illumination often reveal differences, as shown in the figure on the next page. The three "9s" are done in black ink and look essentially

Inks shown under normal (top) and infrared light (bottom) *(Reproduced with permission from Wilson, J. D., et al. "Differentiation of Black Gel Inks Using Optical and Chemical Techniques." Journal of Forensic Science 49 (2004): 364–370. © 2004, ASTM International)*

the same even though different inks were used. When a light-emitting infrared radiation is used, one ink becomes invisible and another glows.

Microscopic examination can reveal physical damage that has been done to paper. Even a simple erasure will damage the top fibers of the paper. To the naked eye the damage may be imperceptible, but under low magnification the damage can be revealed, even if it is overwritten. The erased area may also retain indentations where the pen strokes were removed, and lighting from a side angle (oblique lighting) may reveal

this. Opaque correction fluids can be transparent under UV light, and even simple back-lighting may be all that is needed to see what the correction fluid is covering.

MECHANICAL COPIES

The ability to copy signatures using copy machines, computers, and scanners is a recent method of creating forged signatures. A copy made this way will be a perfect reproduction of a signature, but it will not be handwritten. A signature written in ink on a check sits atop the paper in a relatively thick layer, much like paint on a wall. A photocopy is made with ink, but it is thinner and can be detected with simple microscopic examination. The characteristics of toners used in copiers are quite different from those of inks used in pens and can be seen using a microscope.

Analysis of documents created using scanners and printers relies on the same principles of class and individual characteristics. Rollers and drums may contain scratches or imperfections that can individualize imprints. When a copy is made from a copy machine that has a dirty or scratched surface, trash marks can appear in the copied document. These marks can help link a document to a specific printer and sometimes can help determine an order in which documents were created. Ribbons, inks, and toners can also be analyzed and compared in much the same way as inks from pens and other writing instruments. Thus, while computer technology has complicated the work of the document examiner, it has not made it impossible. Like all forensic disciplines, questioned documents continue to evolve.

5

Counterfeiting Currency

Counterfeiting has a history as old as money itself and was treated more seriously in the past, when the death penalty was used to punish counterfeiters. In the United States, counterfeit currency was a weapon exploited by the British to flood the market, making the Continental (the nickname for the dollar issued in the colonies) all but worthless. The Civil War brought on an abundance of counterfeit currency in the United States, particularly in the Confederate states. The first national currency was adopted during the war in 1862. This act only temporarily slowed counterfeiting, and as a result the United States Secret Service (USSS) was formed in July 1865 with the mission of stopping it. In 2003 the Secret Service was moved from the Treasury Department to the Department of Homeland Security.

In the United States the Treasury Department issues currency and is responsible for deterring counterfeiting and enforcing counterfeit laws. Paper money is produced by the Bureau of Engraving and Printing, while the U.S. Mint produces coins. Because coins have a lower denomination (value) than paper money, they are not as frequently

counterfeited as is paper. The USSS is charged with enforcing counterfeit laws.

COINS

The U.S. Mint is the federal institution responsible for making coins, both for general circulation and trade as well as for commemorative purposes. All coins minted are legal tender, but few of the commemoratives are used as money. Commemoratives are purchased by collectors, and in some cases profits are used to help fund special projects. Since 1982, the commemorative coin program has raised more than $400 million. The Mint traces its history to the late 1700s. In 1792, the Coinage Act was passed by Congress, which led to construction of the first Mint building in Philadelphia. The Philadelphia Mint was the first building built by the federal government after the Constitution was ratified. The Mint now has facilities in Washington, D.C. (headquarters), Denver, San Francisco, West Point, New York, and Fort Knox, Kentucky, in addition to Philadelphia.

Coin manufacturing has not changed much since its inception. At the Mint, the first step is to create round shapes from rolls of the metal

Modern U.S. coins. Notice the different edges—the penny and the nickel are smooth, while the dime and quarter are corrugated. *(zimmytws/Shutterstock)*

A display of modern U.S. paper currency *(Shutterstock)*

that are used. In the case of the penny, the metal is copper coated zinc. The circles punched out are called rounds. The rounds are then heated to soften them and then washed and dried. A specialized mill is used to "upset" the coins, the process that gives them a distinctive rim around the outer edge. The image is then pressed into the coin, a process called striking. Finally, the coins are inspected before being bagged and shipped to banks.

The original act of Congress in 1792 specified that gold, silver, and copper be used for coins. Gold was used for coins worth $10, $5, and $2.50. Dollar coins to nickels were made with silver, and the penny and halfpenny were made of copper. The coins made of precious metals such as silver and gold were made with a ribbed pattern around the edge, which is called reeding, to deter counterfeiting. The tradition survives today, even though precious metals are no longer used for coins meant for general circulation. The last gold coins were produced in 1933. Coins that have a silver appearance have a copper core that is coated with a nickel-copper metal alloy. The penny is made from copper-coated zinc. In 2007, the U.S. Mint made about 7.4 billion pennies, 1.1 billion nickels, 2.1 billion dimes, and 2.8 billion quarters.

The History of Money

Money can be described as a physical object of little intrinsic value that represents wealth. The dollar bill is ink on paper and not worth much; it can be used only as a token to be exchanged for something else. Early human business interactions, such as exchanges of material or services, were based on bartering. For example, one person might exchange meat for water, or meat in exchange for joining a group. These are simple exchanges of goods for goods or goods for services, and the system worked well in early, small social organizations. As civilization drove the development of writing, it also drove the development of a more sophisticated exchange system.

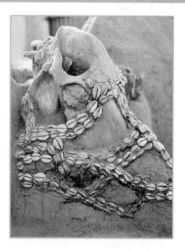

Cowrie shells decorate a cow's skull. These shells were one of the earliest forms of money and are still used today. (*LowellGeorgia/ CORBIS*)

The earliest forms of money were not coins or notes but food such as cows, sheep, and crops. The most widely used form of early money, still seen today, is a small shell called a cowrie shell. The Chinese adopted it as early as 1200 B.C.E. Within a few hundred years the Chinese were also using metal coins made of copper and bronze. Many of these coins were made with holes in the middle to allow them to be strung together like beads, a widespread practice. Native Americans were using chains of clamshells on strings by the middle of the 16th century. These were called wampum. Coins of silver appeared in the West in about 500 B.C.E. and took a form that is recognizable today—rounded with figures and scenes stamped into them. These coins could also be made of gold and other precious metals, but many were made of the less expensive and valued base metals. Modern U.S. coins that are used in general circulation are made of base metals.

(continues)

(continued)

The Chinese also pioneered paper money, with the first examples appearing in about 800 C.E. In a problem often repeated since, so much money was printed that its value fell and prices soared, a situation known as inflation. The problem became so severe that the Chinese abandoned paper currency in the 15th century, and it was only in the 1700s that paper money was seen on a large scale again.

Another important development came in 1816, when Great Britain adopted the gold standard. A set amount of gold was kept in storage or reserve, and paper banknotes could be printed only as long as the value of each note could be supported by the gold reserve. In other words, if the reserve held $1 million worth of gold, only $1 million worth of currency could be printed. This system was adopted to avoid inflation. The United States passed a gold standard in 1900 and created a central bank system and gold reserves that still exist in Fort Knox, Kentucky, and other locations. The Great Depression of the 1930s caused the value of gold to fall, and so the currency system moved away from the gold standard. The year 1972 marked the end of the gold standard in the United States. It has been replaced by a complex worldwide system of currency regulations. The future of money cannot be predicted for certain, but increasingly it appears that electronic exchanges will slowly replace physical coins and paper. Credit and debit cards already handle millions of transactions without any paper notes or coins changing hands.

Because coins are difficult to make and have a relatively small face value, modern counterfeiters usually avoid them except in the case of rare, antique, or specialized high-value coinage. The forensic and investigative techniques used to identify counterfeit coins focus on physical appearance and composition of the metal. Counterfeit coins are usually made not by the pressing method, but by pouring hot liquid metal into a mold. As a result of this process, there can be air bubbles and other imperfections in the coin that would not appear had it been stamped.

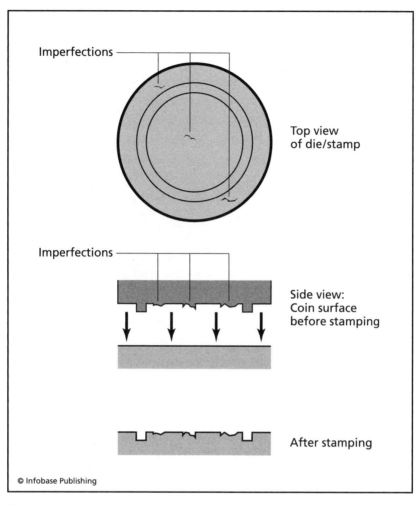

Imperfections

Top view
of die/stamp

Imperfections

Side view:
Coin surface
before stamping

After stamping

© Infobase Publishing

The stamping process will leave the marks on the stamp, including imperfections, on the surface of the coin. Counterfeit coins that are made by pouring molten metal into a mold will not show any such markings.

When a coin is stamped, it will have marks in the surface that forensic scientists call toolmarks or impression evidence. A toolmark is created whenever a metal tool is used on a hard surface. For example, when a screwdriver is scraped along a metal surface, the pattern in the blade of the screwdriver will be imprinted into the metal. Toolmarks and impressions are also created in the surface of a coin from the stamping process.

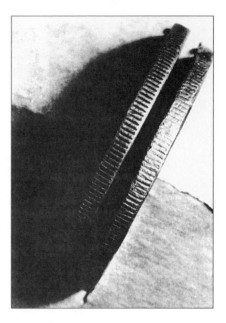

The reeding on coins is a difficult feature for counterfeiters to copy. The coin on the left is genuine and has sharp defined reeding. The coin on the right is counterfeit. *(CORBIS)*

These marks are normal for this procedure; such impressions are not seen when a coin is made by pouring molten metal into a mold.

Reeding patterns along the edges of coins are also difficult to reproduce and give away many counterfeits. Some counterfeiters start with genuine coins and alter dates or other markings to make them appear older or more valuable to collectors. These alterations may be obliterations or what is called overstamping, in which the altered marking is place on top of the original. Many of these forgeries can be detected by microscopic examination.

When chemical analysis is necessary, the metal can be studied by destructive and nondestructive testing. Destructive methods are a last resort because they require that small samples of the coin be removed and dissolved in acid prior to analysis. If the coins are rare or valuable, such damage is often unacceptable. Nondestructive techniques are not perfect, however. They are useful for providing information about the surfaces of a coin, but are not able to penetrate into the coin.

One useful nondestructive technique for the analysis of coins is X-ray fluorescence (XRF), which was discussed in chapter 2. Coins that are made by a government production facility will have small variations in the metal content, but these variations are expected to be relatively small within a

production batch. For example, the composition of pennies changed from copper to copper-coated zinc in 1982, and so pennies minted after 1982 would be expected to have similar composition to one another. Counterfeit coins often show more variation in composition than genuine coins, and XRF can reveal these variations if more than one suspected counterfeit coin is analyzed. Often it is not the primary metal in a coin that suggests counterfeit but rather other metals that are found with the primary metal. In a penny the primary metals are copper and zinc, but other metals inevitably are found in raw metal from which the pennies are made. These metals can include cobalt, iron, nickel, manganese, and others. When the Mint makes coins, the amounts of these trace metals are small but relatively consistent. Unless the exact same raw metal is used to make counterfeits, the levels of trace metals tend to vary much more. Even with a single suspected counterfeit, XRF of trace metals can be of benefit, depending on what is known about the coin should contain if genuine.

An early Secret Service agent is shown breaking up a counterfeiting operation. The Secret Service was formed in 1865 with the charge of protecting the value of the nation's currency. *(Bettmann/CORBIS)*

PAPER CURRENCY

The first paper currency in the United States was issued in 1690 by the Massachusetts Bay Colony. After the Revolutionary War, states continued to issue their own currency into the 1800s. The dollar was adopted as the base unit of currency in 1785, but states continued to issue their own currency into the 19th century. The monetary situation was chaotic. In 1862 the first national currency was issued by the federal government despite the Civil War. The banknotes issued in that year and every year since are legal tender. With the 1862 printing, the basic method had been refined and is still in use today.

Anticounterfeiting features were incorporated from the beginning, including very fine engraving, signatures, and elaborate patterns that are difficult to recreate. The Bureau of Engraving and Printing was established in 1877 and continues to be responsible for printing paper currency. The bureau also prints stamps for the United States Postal Service. Each day the bureau produces approximately 37 million bills.

The first step in making paper money currency is to create an engraving that is called the master die. This is done by hand using a painstaking process, and the die can be used for years. The portrait of Lincoln on the $5 bill was originally carved in 1869. The master die must next be duplicated exactly onto a plate that will produce 32 bills each time it is used. The complex process involves creation of a cast of the die made in plastic and then combined with the other elements of the bill. The plastic relief, called an alto, is placed in an electrolytic bath that causes a metallic coating to form, producing the foundation of the plate. Careful inspection follows. If the alto is deemed acceptable, it is used to make the final metal plate.

For printing, the plate is coated with ink and wiped down so that ink remains in any grooves in the plate. Special paper is rolled across the plates under extremely high pressure. This pressure forces the paper into the inked areas on the plates and transfers it to the paper surface. Since the paper is pressed into the grooves, the bill acquires texture such as fine ridges and grooves. This process of pressing is referred to as intaglio printing, and the texture created by pressing the currency cannot be easily re-created by counterfeiters using any other process.

Until recently, counterfeit currency was created using similar printing methods as the Bureau of Engraving and Printing. The counterfeiter

first created and engraved and then used a pressing technique such as offset printing to create the fake bill. The problems with this method were re-creating the intricate details of the genuine engravings and using the proper colors of ink. The special paper used by the Bureau of Engraving and Printing is a mix of cotton and linen that has a distinctive texture, strength, and fibrous appearance that was hard to match. Another technique used by counterfeiters is called marking up, which alters genuine currency. For example, a counterfeiter could start with a $5 bill and carefully add zeros so that the bill appears at first glance to be worth $50. This type of counterfeit is much easier to detect, but still occurs.

TECHNIQUES OF COUNTERFEITING CURRENCY

Since the 1980s the methods used by counterfeiters have changed, and U.S. currency is changing to address it. As the technology to make color copies improved, so did the use of color copiers to make counterfeit bills. A partial solution was an agreement made with companies that manufacture color copiers. New copiers are programmed to recognize currency and to abort any copies of currency. This addressed one problem just as another was emerging. Personal computers and peripherals such as scanners and color ink-jet printers have made it easier for counterfeiters to create reasonable copies of currency. In 1996 ink-jet counterfeits represented about 1 percent of the counterfeits reported; by 2000 that percentage was more than 50 percent. Another challenge faced by law enforcement is the Internet. Once a high-quality scan is made of a bill, the electronic file version can easily be shared computer to computer.

As computer hardware and software have improved, computer-generated counterfeits have replaced the offset printing method as the preferred counterfeiting technique. As a result, the United States has begun to introduce changes in paper money to thwart computer counterfeiting. In 2005 the publicly disclosed features of the new bills, specifically the $20 bill, include the following:

- a watermark pressed into the paper to the right side of Andrew Jackson's portrait. A watermark is created within the paper itself by pressing the pulped paper onto a mold. Fine writing

paper and official stationary often carries a watermark. The watermark can be seen by holding the paper to a light. Watermarks are not picked up by digital scanners or copiers.

- paper that contains red and blue fibers as well as security threads that fluoresce under certain UV wavelengths.

- a larger portrait that is off-center and that contains more detail. The finer the detail, the more difficult is it to scan, copy, and print.

- more colors in the bill such as peach, green, and blue.

- microprinting in different locations on the bill. For example, there is a light blue, wavy print of "TWENTY USA" to the right of Jackson's portrait; around this the phrase "USA20" is printed repeatedly in letters that cannot be clearly seen except under magnification. Microprinting is found in several locations on the bill.

- to deter mark-ups, "20" is printed in fine gold numerals on the back of the bill surrounding the White House image.

- a special color-changing ink is used for the "20" on the lower right side of the front of the bill. The color of this ink varies depending on the angle from where it is viewed.

- a security thread that is made of plastic and embedded within the paper runs from top to bottom to the left of Jackson's portrait.

These changes will not stop counterfeiting, but they will make it more difficult and will deter people from trying to make money with their scanners and computers. The USSS and other federal government agencies will have to evaluate counterfeiting methods continually and to alter currency as a result. For example, adding microprinting will be effective only as long as scanning and copying equipment are not able to pick up such fine detail. Equipment is available with the necessary resolution to pick up and reproduce microprints, and since the engravings cannot be made any finer, other avenues of deterrence must be used. Even as computer counterfeiting has grown, the number of bogus bills in circulation remains extremely small. The chances of anyone encounter-

How to Verify Money

The U.S. Treasury publishes the following list of suggestions for verifying money to make sure that it is authentic:

- Check the portrait. An authentic bill will have sharp fine lines in the face. A copied bill will have smeared, flat appearance.

- On an authentic bill, the Treasury seal has sharp edges and a deep green color.

- The serial numbers should be even and printed in the same color ink as the Treasury seal.

- The paper should have blue and red fibers dispersed throughout and embedded in the paper. A fake bill will not have the fibers in the paper.

- The portrait should match the denomination. When in doubt, compare the suspect bill to a genuine bill.

- Contact local police or the Secret Service if a fake bill may be detected.

Source: United States Secret Service (2008). "Know Your Money." URL: www.ustreas.gov/usss/money_detect.shtml. Accessed on January 26, 2008.

ing a counterfeited bill is estimated by the government to be about one in 10,000.

Making fake money is the first step in counterfeiting and is not always the hardest. To be profitable, the criminal must make many bills, but he or she has to be cautious about distributing them. Bank employees handle money daily and are trained to detect counterfeits. It makes no sense to make a bag of money and deposit it in a savings account. Professional counterfeiters distribute the fake money and spend it in places less likely than banks to detect the forged notes. The need to spread the fake money around helps to deter counterfeiting.

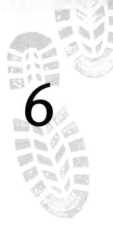

6

Forging Art, History, and Science

Anything that has value can be faked or forged. Money is an obvious example of what is counterfeited, but certainly is not the only example. Art, jewelry, sculpture, historical artifacts, and even scientific findings such as bones can be faked. The goal usually is related to profit and money, but not always. Some, like the Piltdown man hoax, appear to have been perpetrated to make a point, for fun, or for some combination of the two motives. This chapter provides a sampling of some unique fakes and forgeries.

ART OF FORGERY

If someone wants to forge a painting, a map, or other old document, he or she faces several challenges. First is copying the style of the artist or the handwriting of the original writer. As shown in chapter 2, that is not an easy task. Second, the forger has to use materials in the forgery that are consistent with the historical period. If a modern forger tries to copy a painting by Leonardo da Vinci, he or she has to use paints and canvases that could have been available during the years that Leonardo da Vinci

was painting. A trip to the local hobby store could provide canvas and paints, but they would be typical of the early 21st century, not the late 15th and early 16th centuries. Materials that are not period authentic can be quickly detected by an expert, even if the copy was otherwise flawless.

An example is the white pigment. Titanium dioxide (TiO_2), also called anatase, was introduced in 1916. This pigment covered well, but it had a yellowish tint that was later refined to make a pure white. Now it is difficult to get white pigments that are not based on this material.

Forgers attempting to re-create a white paint supposedly from a painting made before 1916 must work hard to avoid using the modern white pigment.

Forgers have plenty of tricks to make paintings appear older than they are. Forgers have been known to use old paintings of little value to uncover a period-authentic canvas to start the counterfeiting process. To re-create the duller, cracked surfaces of older paintings, forgers heat their fresh forgeries, add darkening agents to the paints, or use chemicals to alter the surface. These and other tricks can make the painting look authentic to the eye, but all of those tricks leave traces that can reveal the forgery.

Dr. Walter McCrone, the expert microscopist introduced in chapter 3, examined many paintings in his lifetime. He was an expert in identifying pigments and paints and could often tell just by looking at a tiny sample whether a painting could be authentic or not. Even if two pigments have the same color, under a microscope the particle shapes and sizes are usually different. Analysis using X-ray and other techniques provides the elemental composition that can confirm a microscopic identification. While these tools are used to uncover forgeries, they can also be used to show that a painting is genuine, as one of Dr. McCrone's famous cases illustrates.

The painting entitled *L'Infante Marie Marguerite* (1654, abbreviated as the *Infanta*) is attributed to the artist Diego Velázquez and has been in the Louvre Museum in Paris for nearly 200 years. Another artist, Edouard Manet, is believed to have copied the painting. This was not a forgery, however. Manet officially registered to make a copy in 1859, which was a common practice since artists can learn by copying one another's work. Since Manet became famous himself, the *Infanta* copy

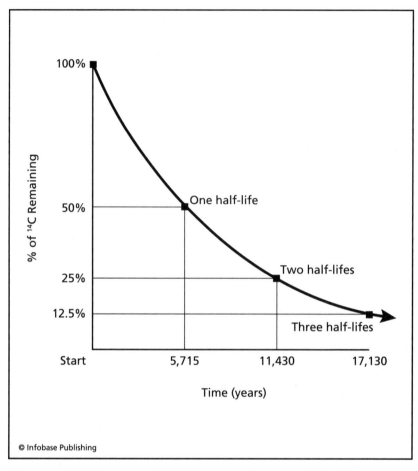

After one half-life has passed, half of the original amount of a radioactive substance remains. Knowing the half-life and the original amount allows scientists to age materials.

he made became quite valuable if located and shown to be authentic. A painting surfaced in the late 1960s that was a good candidate, and in 1983 Dr. McCrone was asked to study it. His concentrated his efforts on three pigments: lead carbonate (white), cobalt blue, and vermilion (a shade of red). He used microscopic examination, chemical analysis, and comparisons to known works of Manet to show that the newly surfaced *Infanta* was authentic to the period and was likely the lost Manet. However, he could not say conclusively that it was this painting. As with

most forgeries, it is easier to prove something is a fake than to prove it is authentic.

Many tools aside from microscopy and microchemistry can be used to unmask fake paintings. Just as handwriting has unique aspects, so does painting. Individual artists use different brushes, brush strokes, and other techniques to create their paintings. A forger might be able to re-create the appearance of a painting roughly, but close examination of the artistic techniques may reveal that the forger did not use the same processes and procedures that the artist did. This aspect of detecting forgeries is similar to detecting forged handwriting. A person may be able to re-create the rough appearance of another's signature, but close examination can reveal inconsistent pen angles, pressure, and order of writing that indicate the signature is a forgery.

The canvas itself can also indicate a forgery. Older canvases were hand-woven and are expected to contain imperfections that would not appear in a modern manufactured canvas. The fibers used in an older canvas would also be of natural origin, not synthetic since synthetic fibers did not become common until after World War II. If wood was used in the frame, dendrochronology (tree ring dating) can determine the time of origin of the frame. Alternate lighting used in document examination can also be helpful, using energy from the X-ray range to the infrared.

Older paintings and artifacts can be dated (approximately) using carbon-14 dating techniques. Carbon-14 is a radioactive isotope of carbon that exists naturally at low levels in the atmosphere. The most abundant isotope of carbon, carbon-12, is not radioactive. Carbon-14 is created by collisions between nitrogen atoms and neutrons.

$$^{14}_{7}N + ^{1}_{0}n \rightarrow ^{14}_{6}C + ^{1}_{1}P$$

In the upper reaches of the atmosphere, the relatively stable nitrogen atom collides with a neutron to produce the radioactive carbon atom. The carbon-14 created can move down closer to the Earth's surface and eventually can be incorporated into carbon dioxide (CO_2). Since carbon-14 is created at a steady rate, the concentration of carbon-14 and CO_2 containing carbon-14 has remained relatively stable over thousands

of years. Carbon-14 is radioactive and breaks down at a steady rate to nitrogen as shown in the equation.

$$^{14}_{6}C \rightarrow ^{14}_{7}N + ^{0}_{-1}e$$

The electron that is emitted is called a beta particle (β), which can be detected by detectors such as Geiger counters.

Like all radioactive materials, carbon-14 has a set half-life that can be used to date items. The half-life ($t_{1/2}$) is 5,715 years, which means that if there were 1,000 atoms of carbon-14 in some original sample, after 5,715 years, 500 atoms of carbon-14 would be left, and the rest would have decayed to nitrogen. After two half-lives (11,430 years), 250 atoms would be left, and so on. After about 10 half-lives or ~57,000 years, the carbon-14 content drops so low that it is undetectable. Scientists can compare the amount of radioactive decay in a fresh carbon sample to an old one, and using half-life can estimate the age of the artifact within a few years but never exactly.

A bone sample being removed for carbon-14 testing. The bone is a human femur that is thought to be medieval. *(PR)*

Large, complex instrumentation is needed to detect carbon-14 atoms in a sample. This photo shows a researcher using an accelerator mass spectrometer for this purpose. *(PR)*

Carbon-14 dating can be used on any object that came from a plant or an animal. Canvas is made from cotton, a plant product. While the cotton plant is alive, it takes in CO_2, including CO_2 that has carbon-14 in it. As long as the plant is living, any carbon-14 that decays is replaced, and so the amount of carbon-14 in the plant tissues remains constant. When the cotton is harvested, intake of carbon-14 stops, and any that decays is not replaced. If cotton is used to make a canvas, the decay of carbon-14 proceeds steadily over time, according to the half-life. By comparing the amount of decay coming from a fresh sample of cotton to the decay in the canvas, the age can be estimated. If the canvas was made in about the year 1470 (approximately 540 years ago), this corresponds to about 1/10th of one half-life of carbon-14. The counts in the older cotton will be about 5 percent lower than the counts from the newer cotton. Carbon-14 dating is used extensively with archaeological artifacts such as parchments and cloth.

The Shroud of Turin provided one of the most famous cases in which carbon-14 dating was successfully used on cloth. Dr. McCrone was also involved, as were a host of scientists, scholars, and officials of the Catholic Church. Because the shroud has religious significance, the debate over its authenticity has been heated and emotional, but the bulk of the evidence to date indicates that the shroud is a very clever fake.

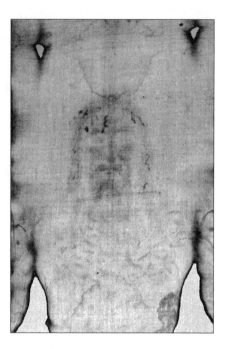

The Shroud of Turin *(Alamy)*

The shroud is a large linen cloth about 4 feet (1.2 m) wide and 14 feet (3 m) long. It appears to show the image of a man with injuries that would be consistent with death by crucifixion. The first mentions of the shroud date from the late 1300s, where it made its way to Italy to be exhibited for the first time in 1389. People were suspicious from the beginning; religious icons and artifacts were frequently counterfeited given that they could be extremely valuable. A local bishop insisted that it was a fake and that he knew so because someone had claimed to have painted it. It has been stored in the cathedral in Turin, Italy, where thousands viewed it and thousands more accepted that the cloth was the burial shroud of Jesus.

In 1988 the church allowed samples to be taken for carbon-14 dating. A small section of the cloth was removed and cut into three sections that went to three different labs for independent testing. The three labs all put the age of the shroud as being made in the late 13th or early 14th century, probably 1260–1390. Dr. McCrone's analysis supported this, and he among others maintained that the cloth was a very clever painting, created by a medieval artist whose motives will never be known. The Catholic Church accepted the scientific results and declared that the shroud was not what so many people had believed over the centuries.

Vinland Map

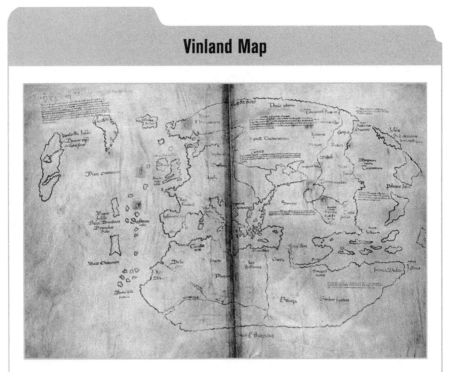

An outline of what appears to the part of the East Coast of North America can be seen in the upper left portion of the Vinland Map. *(AP)*

Sometimes articles are forged not just for profit but as a hoax, and sometimes great debate continues despite rigorous forensic and scientific analysis. One controversial item is the Vinland Map. The map surfaced in the late 1950s and supposedly shows a crude outline of Iceland, Greenland, and the eastern coast of North America, called Vinland. It was purportedly drawn at least 50 years before Columbus sailed. Since it is now known that the Vikings reached North America (Vinland), a logical assumption was that the knowledge used to draw the map came from those early voyages. The parchment was dated using radiocarbon techniques to 1434 C.E. +/- 11 years, well before Columbus sailed, but this did not end the controversy.

The map is currently kept in the Beinecke Rare Book and Manuscript Library at Yale University and is valued at approximately $20

(continues)

(continued)

million, assuming it is authentic. Since 1974 scientific studies, including those of Dr. McCrone, have examined the materials used in the map. Dr. McCrone's microscopic examinations in the early 1970s revealed the presence of anatase, similar to modern TiO_2 pigments. He hypothesized that a forger working in the 1920s had first put down a yellow line and then drawn over it with a black ink. The goal was to create the illusion of old writing, which tends to develop a yellowish tint. The forger used yellow based on finely ground TiO_2. Carbon was detected in the ink, but the amount was and is still too small to date using existing carbon-14 dating technologies. McCrone was convinced that he could see the two layers clearly—the yellow on the bottom and the black drawn on top of it. The microscopic examination was supported by elemental analysis using XRD, SEM, and other techniques.

In 1987 another study was conducted by scientists in California to prove that the map was authentic. The scientists also found titanium on the map, but at relatively low levels. They suggested that it came not from the ink but from the parchment. The lines, they concluded, are separate but did not originate that way. Rather, one ink was used to draw the map, and over time, it separated into the yellow and the black layers observed.

Another scientific paper in 1990, written by a scientist at the Smithsonian Institution, supported Dr. McCrone based on a statistical evaluation of the 1987 data. This report showed a statistically significant difference between titanium levels in the parchment and levels in the ink. The controversy is still ongoing. A paper published in the respected journal *Analytical Chemistry* in 2002 reported that microspectrophotometry indicated that the ink used in the Vinland Map was not period authentic. Follow-up correspondence in 2003 argued that the ink could have been authentic, and yet another note in 2004 claimed that it was not. More data is clearly needed before all sides reach a conclusion.

FINGERPRINTS

Once fingerprints were found to be useful in the investigation of crimes, criminals realized the value in forging fingerprints. Police officers have also been known to forge fingerprints in an attempt to build their case against a suspect. The first recorded instance of fingerprint forgery occurred in India in 1903, which was about the same time that fingerprints were being recognized as a valuable crime-fighting tool. Thirteen years later, Indian officials reported that moneylenders had created fake fingerprint-making molds that were used to mark notes in much the same way signatures are used today. The forgers started by making an impression of the fingerprint they wished to forge in a thick waxy material. Then they filled this impression with a gummy substance to create a kind of fake finger, which they used to forge the fingerprint. In London in 1938, an attorney demonstrated a method of obtaining fingerprints by placing wax on the fingers of a glove and having the victim shake hands. The victim's fingerprint was pressed into the wax, allowing a forger to make a fake fingerprint from this mold.

As a mark of individuality, fingerprints have a long history. Ancient cultures such as the Babylonians and the Chinese used them as a signature, although it is not known if they recognized that fingerprints were unique to each individual. Modern interest in fingerprints as an aid to law enforcement (also called dactyloscopy) traces back to the middle of the 19th century. In 1858 the chief administrator officer of the East India Company, Sir John Herschel, was faced with problems of impersonations among native workers. To combat this, he adopted the ancient traditions and began to use handprints as a form of identifier on documents. Shortly, he used only the fingerprints from the last joint to the tip, and by 1877 was using the same procedure to assist in identifying prisoners. In 1880 Scottish physician Henry Faulds published an article in *Nature*, a respected scientific journal, concerning the identification of criminals based on the uniqueness of fingerprints. This led to further advances in the new field, and in 1892 Sir Francis Galton, a cousin to Charles Darwin, published a book entitled *Finger Prints*. In 1894 Scotland Yard adopted fingerprints to go along with the Bertillon system of body measurements (anthropometry) used at the time for criminal identification. Across the Atlantic, Juan Vucetich, an Argentinean police official who was maintaining a large catalog of fingerprints, in 1892 recorded the

first case in which a fingerprint was used to solve a crime. A mother had murdered her son and blamed a neighbor, but finding her bloody fingerprints on a doorpost was enough to elicit her confession. Vucetich would later develop a fingerprint classification system that is still used in much of South America.

The new century saw increasing interest in and acceptance of fingerprints in law enforcement. In 1900 Sir Edward Richard Henry of the Metropolitan Police Force in London published "Classification and Use of Finger Prints," based on the ideas put forth by Galton eight years earlier. The work formalized these ideas into a system of fingerprint classification that has come to be known as the Henry system, variations and extensions of which are used in the United States, Europe, and elsewhere. By 1902 the United States had begun to adopt fingerprinting for identification with the New York Civil Service, followed in 1903 by adoption at Sing Sing prison. The military soon followed. In 1903 a deathblow was struck to the Bertillon system with an incident at Leavenworth prison in Kansas. Two men were found to have identical anthropometric measurements but different fingerprints, and from then on, fingerprints rapidly became the primary physical feature used for identification across the country. By 1915 the first professional society in the area of fingerprinting, the International Association of Identification (IAI), was formed. In 1923 the International Association of Chiefs of Police established the National Bureau of Criminal Identification (NBCI) at Leavenworth. The next year an Identification Division was established at the Bureau of Investigation, the precursor of the Federal Bureau of Investigators (FBI), and they merged the NBCI collection with theirs to create a national centralized repository for fingerprint information. This collection, now housed within the FBI, is the largest in the world. In the late 1960s the FBI began research into the use of digital and computer technologies to assist in fingerprint classification and identification, with the first operable reader available in 1972. This technology continues to evolve from the current system of automated fingerprint identification (AFIS).

A sensational case of fingerprinting occurred in the United States in 1967. William De Palma was convicted of robbing a bank based on fingerprint evidence recovered at the scene. Two of the bank tellers also identified De Palma in a police lineup. However, 13 witnesses swore that De Palma was with them at the time of the robbery, serving them food as

part of his job. De Palma was convicted and sent to jail, but secured the services of a private detective who uncovered the fraud. It took nearly four years for him to discover that the police officer who claimed to have recovered the prints at the scene had actually used a photocopy of De Palma's fingerprint card to create the forgery. In a recent case in Poland, a fingerprint that supposedly came from a crime scene was revealed as a forgery not because of the print, but because of the surface where it was

Scientific Forgery

A theory has been proposed that birds are the living remnants of the dinosaurs. A find in China of an Archaeopteryx fossil announced in the late 1990s supported the notion that birds evolved from a type of carnivorous dinosaur. Excitement was high that a fossil could show conclusively that birds evolved from dinosaurs. Soon after, a fossil that originated in China (called Archaeoraptor) was uncovered and for a time, appeared to prove the link. The fossil had intriguing features, some clearly related to birds, others clearly dinosaurlike. Unfortunately, it was too good to be true. Scientific analysis of the fossil showed it to be a

Beijing paleontologist Xu Xing and Steven Czerkas, of the Dinosaur Museum in Blanding, Utah, hold a "missing link" fossil at an October 15, 1999, news conference at the NGS in Washington, D.C. The *Archaeoraptor liaoningensis* fossil is later deemed a "fake" fossil *(AP/ Dennis Cook)*

clever but obvious forgery that was constructed in three layers. The bottom layer is a large piece of rock, while the middle layer is composed of grout, the material that builders use to secure tiles to floors. The grout was used to secure 23 pieces of rock with embedded bones and other shards to create a composite fossil with birdlike feathers and teeth and a dinosaurlike tail. To uncover the fraud, scientists used a CT scanner much like those used in hospitals and other tools.

found. The fingerprint was on a complex surface, yet the tape lift had no sign of the patterns that would be expected if the lift had really been taken from that surface.

SCIENTIFIC FAKES AND FORGERIES

Sound scientific testing and analysis is the key to uncovering fakes, but science is not without its own frauds. Some are perpetrated to make a point, some as a joke, but others are true frauds, designed specifically to deceive the public and other scientists. If the fraud is created by scientists, uncovering it can be extremely difficult. One advantage scientists have is peer review, the system in science by which results are reviewed, studied, and debated in public by other scientists. Eventually, the fraud comes to light, but in some cases, as with the Piltdown man, that may take years. Carbon-14 dating is not useful for these cases because there is no carbon; even if there was, any real fossil would be much older than 57,000 years, which is the limit for carbon-14 method. There are other dating methods that can be used, as was the case with the Piltdown skull scandal, which played out in the middle of the 20th century.

HUMAN BONES: THE PILTDOWN MAN

As in the Archaeoraptor case, there has been a desire to find a missing evolutionary link between humans and their primate ancestors of monkeys and apes. The fever was especially strong in the later part of the 19th century and the early part of the 20th century since there was still considerable doubt about the theory of evolution. Darwin had published his theory of evolution in 1859, and it was greeted with as much controversy as excitement. Many people did not want to believe that humans had anything in common with apes, let alone a close evolutionary relationship. There were those who were as motivated to see Darwin's theories proved wrong as were those who believed it to be right, particularly when it came to human beings.

To add to the situation, fossils of what are now called Neanderthals had been already been found in other parts of Europe in about the turn of the last century, and these proto-humans were strong candidates for the missing link or something related to it. The country in which fossils of the missing link were found could rightfully claim to be the

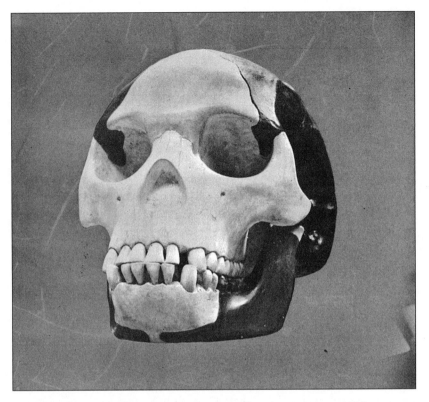

The reconstructed Piltdown skull (1913), where the darker parts are the fragments found and the lighter parts are copies of the reverse side, and the other parts are based on conjecture. *(Getty)*

place where humans began. The national rivalries no doubt added to the incentive for a hoax. It came in 1911, when Charles Dawson found some bone fragments in a gravel pit in Piltdown, a town in Sussex, England. Further exploration and excavation let to more discoveries and an announcement in December 1912 of their findings and their belief that the skull they had recovered was that of the missing link and the first true human. The skull had a skull cavity much like a modern human but a jaw that was more apelike. Further findings nearby seemed to confirm this idea, and the Piltdown man found his way into textbooks and general acceptance despite lingering skepticism. The skepticism grew over the years as findings around the world did not support the authenticity of the Piltdown man's unique mix of human and ape features.

The hoax unraveled in the late 1940s, when modern dating techniques showed that the skull and jaw were not ancient. The skull was that of a modern human that had been boiled and stained. An announcement in 1953 put an end to the hoax and forced a revision of ideas about human evolution. Despite decades of investigation since, no one can be certain of the hoaxer's identity.

COUNTERFEIT DRUGS

Prescription drugs are a huge industry in the United States. Many of the drugs draw a high price, creating plenty incentives for counterfeiters to step in and take advantage of the public. The U.S. Food and Drug Administration (FDA) is the federal agency responsible for regulating the drug supply. In a recent report the FDA noted that the cases of counterfeit drugs quadrupled from the 1990s to 2002. The latest figures available indicate that 10 percent of the drugs sold globally are counterfeit. Estimates from the World Health Organization are that 1 percent of the drugs in the United States are counterfeit, with the percentage reaching 30 percent in undeveloped nations. Counterfeit drugs are especially worrisome because they can have serious consequences for the health of those taking them.

A counterfeit drug is defined as any that has a composition that differs from that stated on the label. There may be less-active ingredients or none at all even though the tablets, pills, or capsules may look identical to the genuine drug. The drug is also classified as counterfeit if the active ingredient was made by someone or some group other than the company listed on the label. A drug that has passed its expiration date and is relabeled to appear fresh is also considered counterfeit.

When currency or fingerprints are forged, the document, bill, or print remains as evidence and can be studied and evaluated. With a counterfeit drug, the evidence is usually destroyed when the drug is taken. If a person takes a counterfeit and the symptoms do not improve, it might be assumed that the drug did not work. It is unlikely to occur to the patient or to the doctor that the patient never took the drug prescribed. In the worst case, a counterfeit drug may contain ingredients that are harmful to the person taking it.

As with counterfeit currency, many countermeasures have been proposed by government officials. The first is a drug pedigree that would

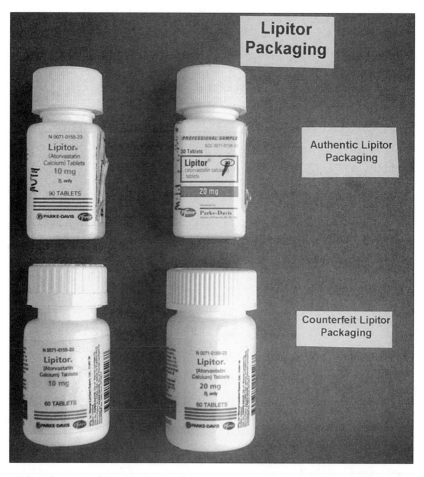

Real and counterfeit Lipitor®, one of the most widely prescribed drugs in the United States, which is used to treat high cholesterol *(AP/James A. Finley)*

accompany every drug shipment. The pedigree would specify when the drug was made, how it was shipped and stored, who handled it, and how. This document would be complete, but could also be forged, and for the thousands of drugs prescribed every day, it would be a difficult procedure to implement widely. A second proposed solution is the use of tags. These tags would transmit a weak radio signal that could track a drug shipment from manufacturing to final delivery. When the technology matures, this approach may be useful in combating many kinds of fakes and forgeries beyond prescription drugs.

7

Conclusion:
The Future of Fakes,
Forgeries, and Counterfeits

Anything of value can be the target of fakes, forgeries, and counter-
feiting. This situation will not change. In the modern world, even
drugs are faked. What will change is how and what is faked, forged,
and counterfeited. For example, drugs and medicines were not coun-
terfeited to any significant degree until they became valuable. Forgers,
no matter what their target, will continue to adapt the latest technology
to their criminal activity. The methods will also change to keep pace
with those who identify forgeries and enforce the laws against it. The
digital age has changed the way people exchange information. What
was once written in books and letters is now transmitted by e-mail and
computer file. Paper money and checks are being used less as credit
cards are used more. Yet people still create paintings and sculpture, the
most valuable of which will always tempt forgers.

Money, which is a prime target of forgery through counterfeiting,
has moved a long way from the seashells first used. Coinage gave way
to paper currency in many applications, and now cards and electronic
cash are slowly replacing currency. All the while, governments that make
money and control its supply have battled counterfeiters. For documents

and counterfeiting, the use of computer hardware, peripherals, and software will undoubtedly increase. U.S. currency will have to change more often to keep pace. Engravings are at the limit of resolution using the intaglio process, and so new countermeasures will have to be used. The European Union has introduced paper currency based on the euro that may be an indicator of how currency will look in the future. Euro bills are highly colored and like U.S. currency have a raised texture, a security thread, and color-changing ink. Higher denomination euro bills also have a foil hologram on the bill, a feature that cannot be duplicated using existing computer technologies.

The world of questioned documents, fakes, and forgeries has changed dramatically with the advent of widespread use and availability of computers, printers, and scanners. The digital age has also changed the way in which money is made and spent, closing some doors to forgers while opening others. Regardless, there will always be a race between those who design and issue legitimate currency and those who counterfeit it. Eventually, counterfeiters always catch up with even the most advanced countermeasures. The future of fakes and forgeries will come down to what it always has been—an endless race between those who create forgeries and those who detect them.

GLOSSARY

absorption in this context, a process by which color is determined by what a sample absorbs or subtracts from the original light. Shining light through a test tube of red food coloring is an example; the food coloring molecules absorb all the other wavelengths.

accidental characteristics characteristics that are imparted through accident or fault. For example, if a roller in a laser printer is scratched at the factory, that scratch is called an accidental characteristic.

civil law law that deals with disputes between parties

class characteristics features of evidence that can be used to classify it into a smaller group. For example, computer printers can be classified as dot-matrix, ink-jet, or laser.

criminalistics an early term describing what is today called forensic science. Generally, criminalistics was the application of science to matters of the law. Today the term usually refers to the analysis of trace and other types of physical evidence such as glass or tape.

colorant a substance that can impart or is colored such as dyes or pigments; a substance that absorbs or emits energy in the visible range

common source associating two or more items or exhibit of evidence to one and only one possible source

compound microscope a magnification system that employs two magnification lens systems, an ocular or eyepiece and a sample or objective lens. In simple terms, the objective lens creates an image that is magnified again by the ocular lens.

dot matrix printer a computer printing technology that uses a ribbon and pins to generate printing

drawing a method of forging a signature by study and careful reproduction

electronic signature a unique code, image, or other unique electronic identifier that is used to certify that a specific person is the source of

the document and that the same person can vouch for the contents of the document

exhibit a piece or individual item of physical evidence

forgery an object that is not genuine and is made in an attempt to deceive

fraud attempting to present something (like money, a signature, and so fourth) that is not genuine

fluorescence immediate emission of a photon from an excited state

half-life the amount of time for half of the original amount of a substance ingested or existing in the body to be eliminated or converted to another substance

identification in forensic science, the linking of something unambiguously to one and only one possible source

intaglio printing a process used in making currency that creates ridges and grooves in the printed substrate; an anticounterfeiting measure

machine defect/machine wear another term to describe wear characteristics.

microspectrophotometery use of a microscope in conjunction with a spectrometer

nonimpact printing printing that does not rely on an impact between metal and paper to produce an image. An ink-jet printer uses nonimpact techniques.

physical match the linking of two parts to each other by way of fitting, just like fitting puzzle pieces. For example, suppose a piece of duct tape is ripped from a roll. The torn edges of the roll will match perfectly to the torn piece and none other.

pigment a colorant that is not soluble and that is suspended in a solution rather than dissolved in it

polarizing light microscope (PLM) a type of compound microscope that exploits polarized light to determine chemical structural information

real image an image that can be captured at a specific point in space. A movie projector creates a real image that is captured in focus on the screen. Move the screen, and the image becomes blurred.

reflectance in this context, color perception produced based on what wavelengths of light are reflected from a sample. The ink on this page appears black because it reflects little or no visible light; the appearance of black is created by little or no reflectance of white light.

ROY G BIV an acronym for the simple colors of visible light as follows: red (wavelength of approximately 700 nm wavelength), orange, yellow, green, blue indigo, and violet (approximately 400nm)

scanning electron microscopy (SEM) an imaging technique that uses interaction of a sample with electrons to create an image

spectrometry/spectrophotometry an instrumentation method of analysis that studies how electromagnetic energy interacts with matter. One of the simplest spectrophotometric instruments is a colorimeter, which studies how light (visible electromagnetic radiation) interacts with matter.

toner a waxy particulate mixture used in laser printers and copiers to deliver colorant to a substrate that is then heat-affixed

tracing a method of forging a signature by literally tracing the original

vehicle the solvent in which a colorant is dissolved; applies to inks and paints

virtual image an image that does not exist in space. It can only be created in the eye by looking through a lens. A magnifying glass creates a virtual image that exists only in the eye of the person looking through the lens.

wear patterns (wear characteristics) patterns on evidence that are acquired though use and not from the way in which they were produced. A typewriter key can get scratched over time and the scratches are called wear characteristics.

FURTHER READING

General Textbooks and References

The books listed below address forensic science topics such as laws of evidence. All contain material relating to document examination.

DeForest, P. R., R. E. Gaensslen, and H. C. Lee. *Forensic Science: An Introduction to Criminalistics.* New York: McGraw-Hill, 1983. This is a basic textbook in which little or no prior knowledge of science has been assumed. Most of the book is devoted to a careful exploration of the importance of physical evidence.

Eckert, William E., ed. *Introduction to Forensic Sciences,* 2nd ed. Boca Raton, Fla.: CRC Press, 1996. Eckert, a foremost authority in forensic medicine, presents each of the distinct fields that collectively make up the forensic sciences in a logical, relatively nontechnical fashion. Each chapter is written by a well-known expert in his/her respective field. When appropriate, the various methods of applying these sciences in different countries are covered.

James, Stuart H., and Jon J. Nordby, eds. *Forensic Science: An Introduction to Scientific and Investigative Techniques,* 2nd ed. Boca Raton, Fla.: CRC Press, 2006. Written by highly respected forensic scientists and legal practitioners, the book covers the latest theories and practices in areas such as DNA testing, toxicology, chemistry of explosives and arson, and vehicle accident reconstruction. The second edition offers a presentation of criminalistics and related laboratory subjects.

Nickell, Joe N., and John F. Fisher. *Crime Science: Methods of Forensic Detection.* Lexington: University Press of Kentucky, 1998. A comprehensive primer of forensic investigation for the lay reader. After an introductory chapter details the proper protocol for securing a crime scene, nine chapters focus on different forms of evidence.

Nordby, Jon J. *Dead Reckoning The Art of Forensic Detection.* Boca Raton, Fla.: CRC Press, 2000. This is a collection of modern-day true crime cases that effectively employ the science of deductive reasoning and critical thinking to descriptively capture and re-create the details surrounding a diverse collection of crimes.

Miscellaneous

Bartlett, Kate. "Piltdown Man: Britain's Greatest Hoax." Available online. URL: http://www.bbc.co.uk/history/archaeology/excavations_techniques/piltdown_man_01.shtml. Accessed January 21, 2008. An excellent centralized source about this incident.

Dam, Julie K. L. "The Faking Game: Demand Keeps Growing For Big-Name Art—And Brazen Forgers Are Happy to Provide an Endless Supply." *Time Magazine.* (1997): 149. Available online. URL: http://www.time.com/time/magazine/1997/int/970310/aart.the_faking.html. Accessed on January 28, 2008. An interesting discussion of modern art forgery.

Encyclopedia Britannica. "Turin, Shroud of." Available online. URL: http://www.serch.eb.com/eb/article-9073835. Accessed on January 28, 2008. An overview of the shroud's history.

Geller, B., J. Almog, et al. "A Chronological Review of Fingerprint Forgery." *Journal of Forensic Sciences* 44–45 (1999): 963–968. An overview of fingerprint forgery.

Hess, G. "Fighting Fakes." *Chemical and Engineering News* 86, no. 1 (2008): 18–19. This article provides current statistics and discusses efforts by U.S. officials to combat counterfeit drugs.

Kurland, M. *A Gallery of Rogues, Portraits in True Crime.* New York: Prentice Hall General Reference, 1994. Introduces criminals and a few forgers.

McCrone, W. C. *Judgment Day for the Shroud of Turin.* Chicago: McCrone Research Institute, 1996. Dr. McCrone's account of his work on this artifact as well as the results of other analysis that helped uncover the shroud as a fake.

Rowe, T., R. A. Ketcham, et al. "The Archaeoraptor Forgery." *Nature* 410, (2001): 539–540. Discusses the dinosaur fossil forgery.

Questioned Documents

Ellen, D. *The Scientific Examination of Documents, Methods and Techniques*. 2nd ed. London: Taylor and Francis, 1997. A thorough treatment of modern document examination.

Hilton, O. *Scientific Examination of Questioned Documents*. Rev. ed. Boca Raton, Fla.: CRC Press, 1993. One of the classic texts.

Koppenhaver, K. M. *Attorney's Guide to Document Examination*. Westport, Conn.: Quorum Books, 2002. This book covers mostly legal issues of forensic document examination.

Web Sites

General

Bureau of Engraving and Printing. Available online. URL: www.moneyfactory.com. Accessed on January 21, 2008. This Web site is designed to be an easy-to-use resource for information on security documents. A search engine is available to help you locate information. The navigation bars on the top and left side of each page will help you move around the site efficiently.

Nikon's Microscopy University. Available online. URL: www.microscopyu.com. Accessed on January 21, 2008. This is a helpful Web site that is designed to provide an educational forum for all aspects of optical microscopy, digital imaging, and photomicrography.

Reddy's Forensic Page. Available online. URL: www.forensicpage.com. Accessed on January 21, 2008. A good collection of general forensic links.

United States Mint. Available online. URL: www.usmint.gov. Accessed on January 21, 2008. Describes the Mint, its features and function, and U.S. coinage.

Zeno's Forensic Page. Available online. URL: www.forensic.to. Accessed on January 21, 2008. This site provides information on forensic science, forensic psychiatry, and other aspects of forensic evidence for more than 15 years.

Professional Organizations and Societies

American Academy of Forensic Sciences (AAFS). Available online. URL: www.aafs.org. Accessed on January 21, 2008.

American Society of Questioned Document Examiners (ASQDE). Available online. URL: http://www.asqde.org/. Accessed on January 21, 2008.

Association of Certified Fraud Examiners (AFCE). Available online. URL: http://www.acfe.com/. Accessed on January 21, 2008.

International Association of Identification (IAI). Available online. URL: www.theiai.org. Accessed on January 21, 2008.

INDEX

Italic page numbers indicate illustrations